DOG RUN

DOG RUN

Michael Crouser

VIKING STUDIO

VIKING STUDIO
Published by the Penguin Group
Penguin Group (USA) Inc., 375 Hudson Street, New York, New York 10014, U.S.A.
Penguin Group (Canada), 90 Eglinton Avenue East, Suite 700, Toronto, Ontario, Canada M4P 2Y3
(a division of Pearson Penguin Canada Inc.) · Penguin Books Ltd, 80 Strand, London WC2R 0RL,
England · Penguin Ireland, 25 St. Stephen's Green, Dublin 2, Ireland (a division of Penguin Books
Ltd) · Penguin Books Australia Ltd, 250 Camberwell Road, Camberwell, Victoria 3124, Australia
(a division of Pearson Australia Group Pty Ltd) · Penguin Books India Pvt Ltd, 11 Community
Centre, Panchsheel Park, New Delhi – 110 017, India · Penguin Group (NZ), 67 Apollo Drive,
Rosedale, North Shore 0632, New Zealand (a division of Pearson New Zealand Ltd) · Penguin
Books (South Africa) (Pty) Ltd, 24 Sturdee Avenue, Rosebank, Johannesburg 2196, South Africa

Penguin Books Ltd, Registered Offices: 80 Strand, London WC2R 0RL, England

First published in 2008 by Viking Studio, a member of Penguin Group (USA) Inc.

1 3 5 7 9 10 8 6 4 2

Copyright © Michael Crouser, 2008
All rights reserved

Some of the photographs appeared in *Minnesota Monthly*.

ISBN 978-0-670-02037-9

Printed in Spain by Imago
Set in Bitstream Arrus · Designed by Amy Hill

In memory of my mom,

Carmen Crouser,

and Chelsea the yorkie . . .

a good little dog who didn't always

play well with others.

Foreword

Dogs have been with us so long it's nearly impossible for us to look at them as if they weren't a part of human lives. They are our longtime companions, one of the small number of species that have signed on to join us in the human enterprise. And though this long-ago choice—when some pack came near our fires and perhaps looked into our faces with a mixture of interest, hunger and fellow feeling we might well recognize today—has brought their species a world of complications (the grief of abandonment, the loneliness of the cage, the indignity of bows in the hair, the wild artifice of breeder and groomer), it has also brought them both pleasure and joy and has allowed them to grow numerous as now so many of their wild kin are not. They've become, in a few millennia, inseparable from the human world; we can't imagine them without us.

Thus dogs are most often photographed, as they are seen, in relation to us. We remark on the resemblance between owner and pet, we notice dogs noticing our ways and we dress them up and pose them. In the nineteenth century, photographers

equipped bulldogs with glasses and cigars, schnauzers with hats and ties, and there are famous contemporary photographs, too, in which dogs serve us as mirrors and semblances.

But Michael Crouser is after something else, which is to capture the dog as if we weren't there. We are, of course, sitting around the perimeter of the dog run, that distinctly urban place where the canine citizens of the city are off leash, on their own together. We're watching the show, supervising, chatting with the other people who love their four-legged pals as much as we do, but what exactly is happening for the dogs?

Michael Crouser's pictures are formally gorgeous, with their deep blacks and their austere grays, their low angle of vision and their balletic arrangement of forms within the picture frame, the beautiful dynamics of bodies in space. But their signature achievement has to do with subject matter, the way Crouser allows us to see the wildness of the arena in which these otherwise civilized pets find themselves. It's strange to remember that these beasts, with their bared fangs and muddy tongues,

their wild snarls and beautiful leaps, live in apartments, march on leashes, obey a set of civil codes. Here the tension between their managed, urbane lives and what remains of an inherent wildness is made clear. Their sweetness is here, and their playfulness, but there's also a sly gleam in the eye, an unveiled ferocity, even the stark lineaments of fear. These pictures ask us to see that, in what William Blake called the "chartered streets" of our city, there's a place where our dogs, at least, might at any moment be thrown to the ground, or lifted up in battle, might whirl to face or deflect their assailants, where a moment's encounter might well lead to sex or war. That is the lesson, when the double gates of the dog run swing open, entrance to an arena of comedy and ferocity, of moments of startling grace and, as these intimate and unexpected photos attest, fierce beauty.

—Mark Doty

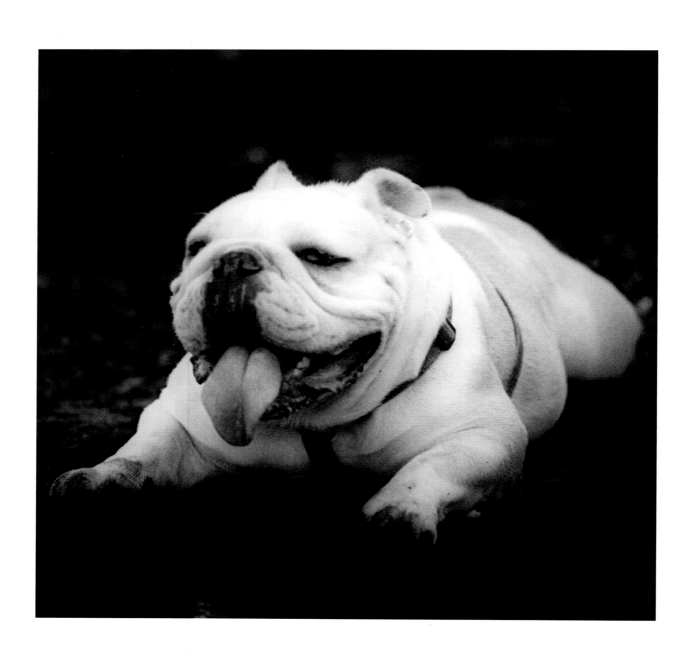

"One thing I would never photograph is a dog lying in the mud."

—Diane Arbus

DOG RUN

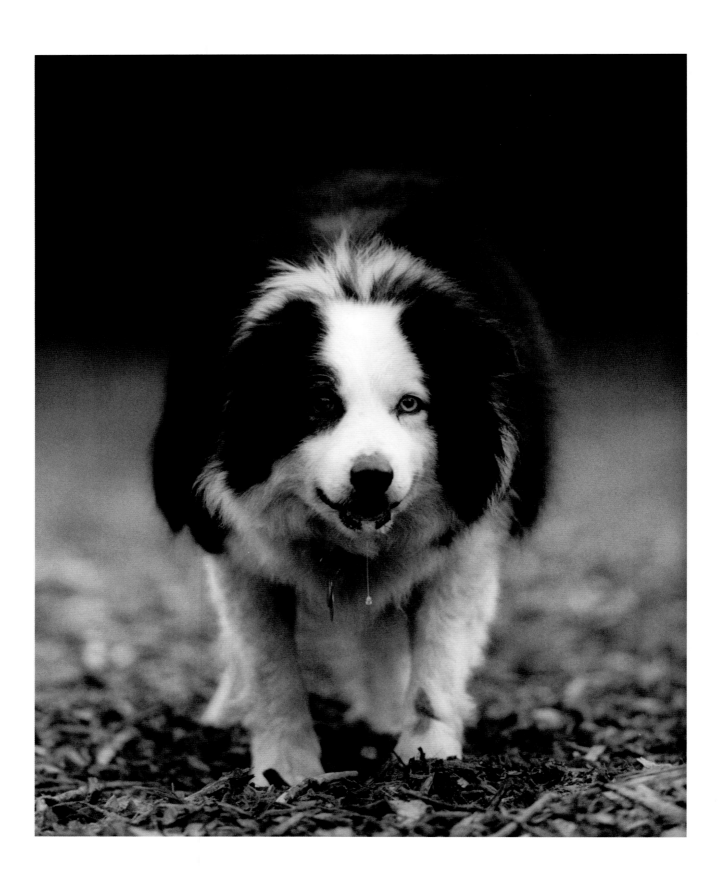

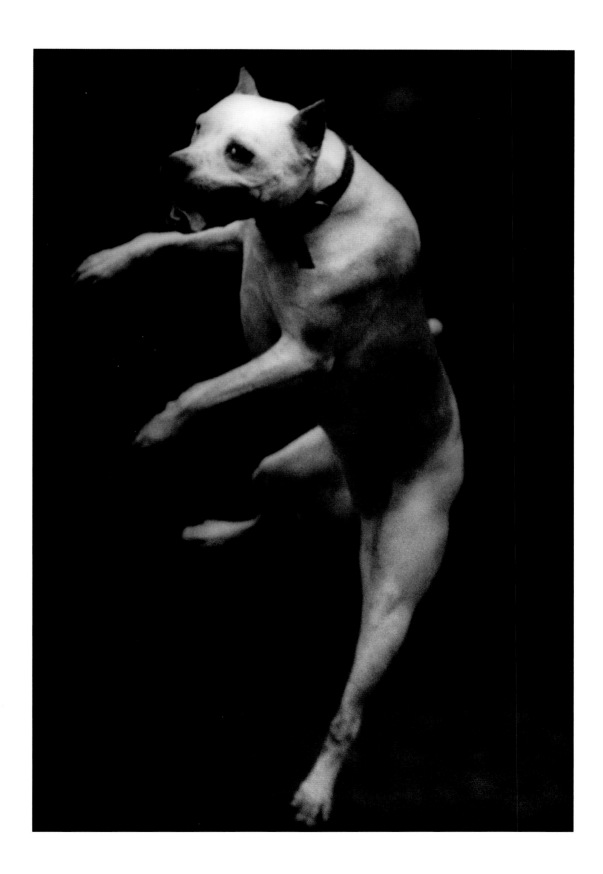

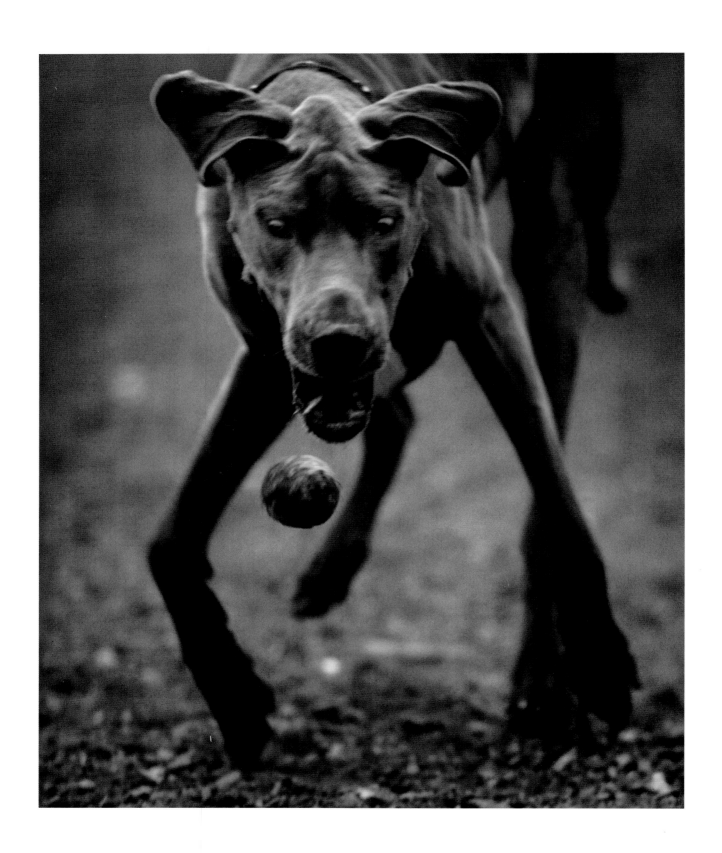

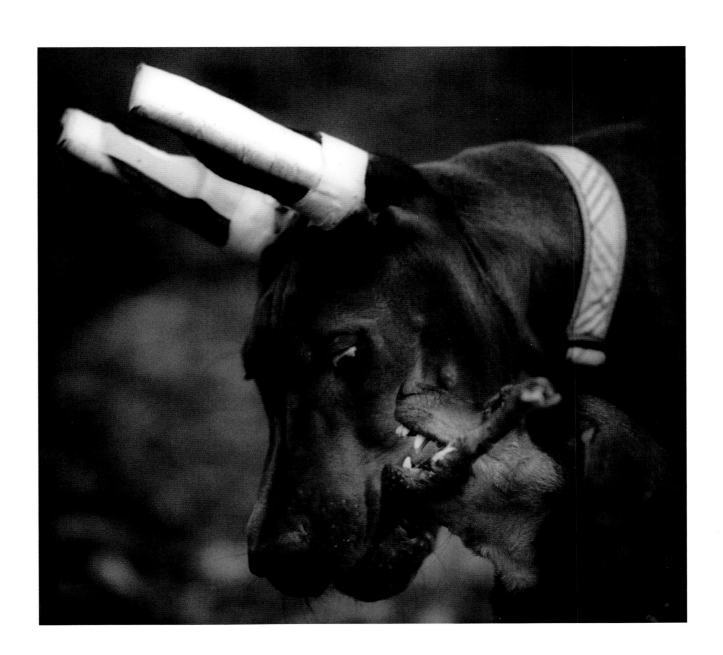

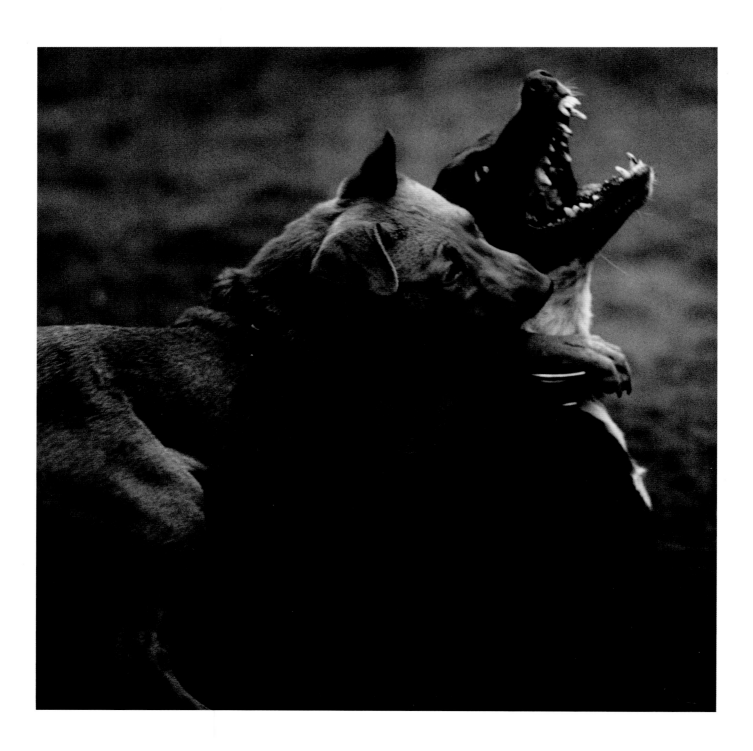

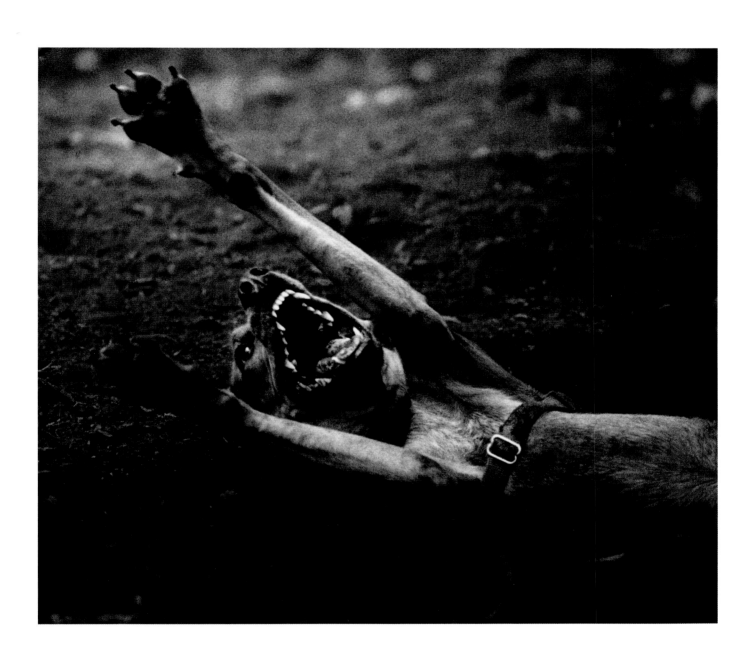

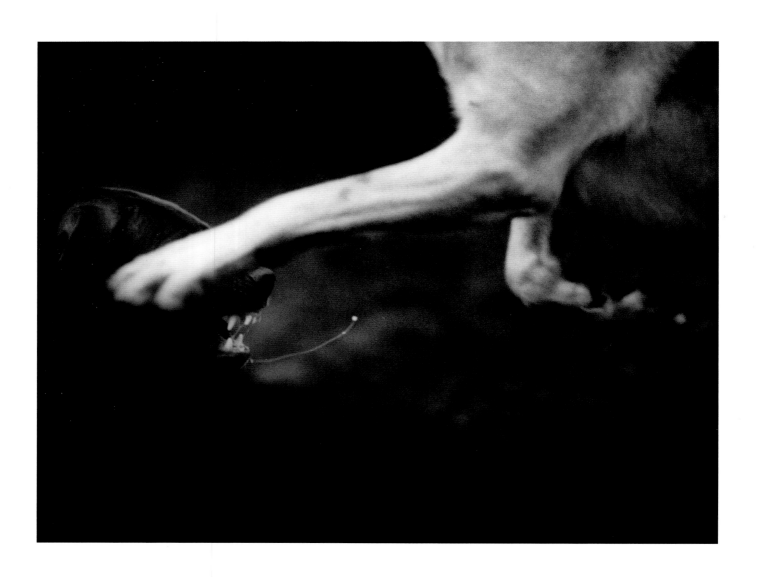

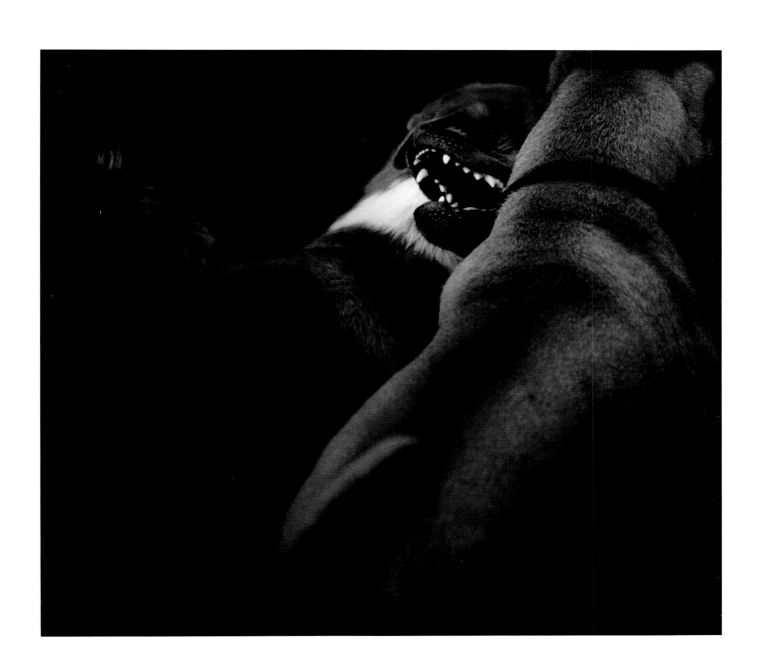

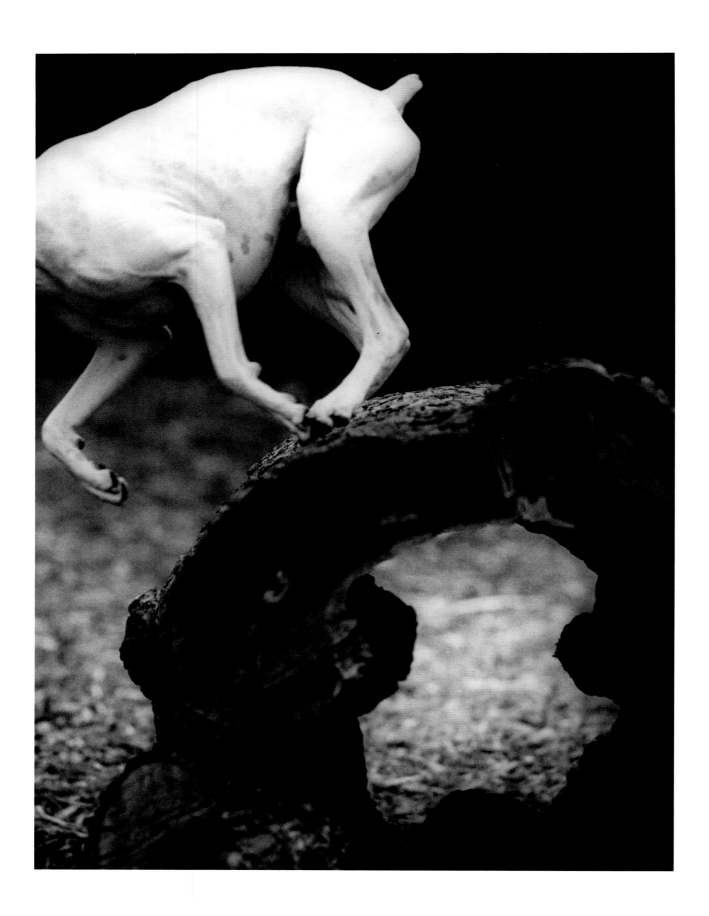

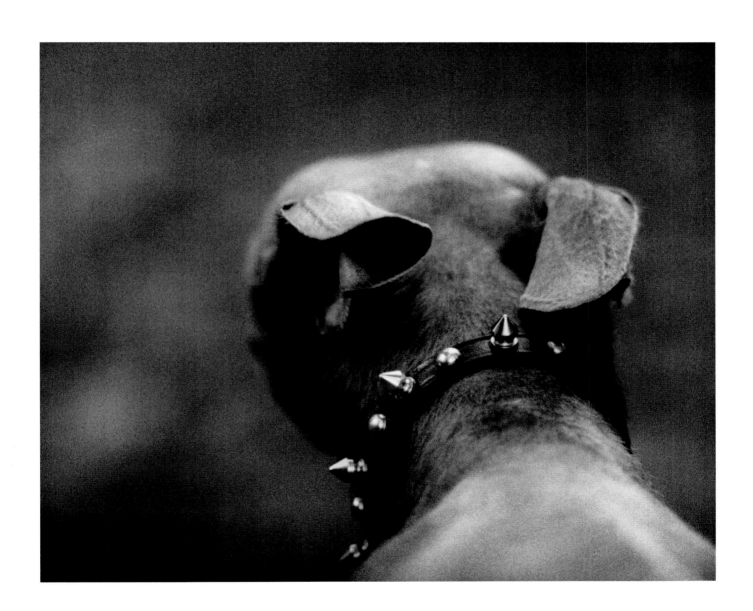

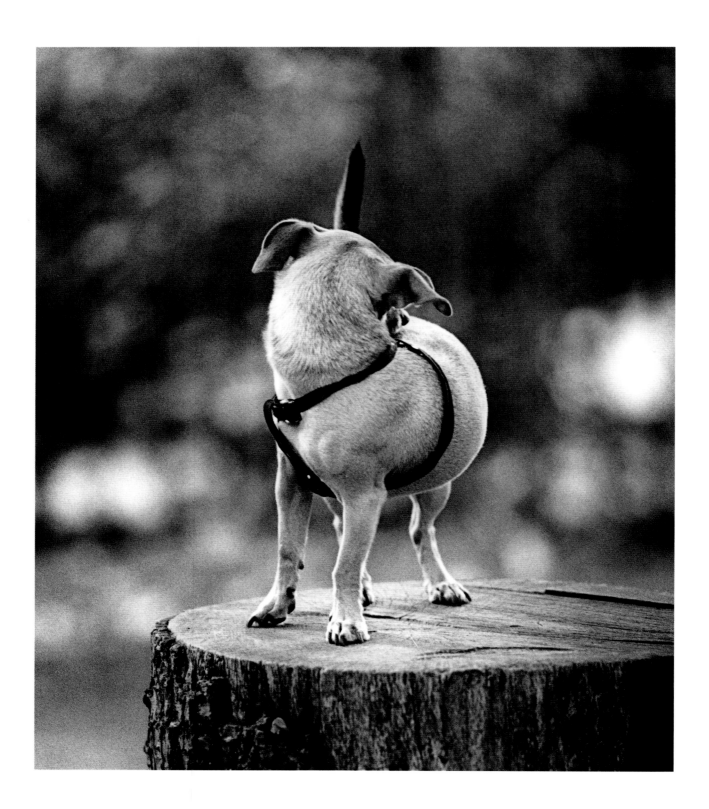

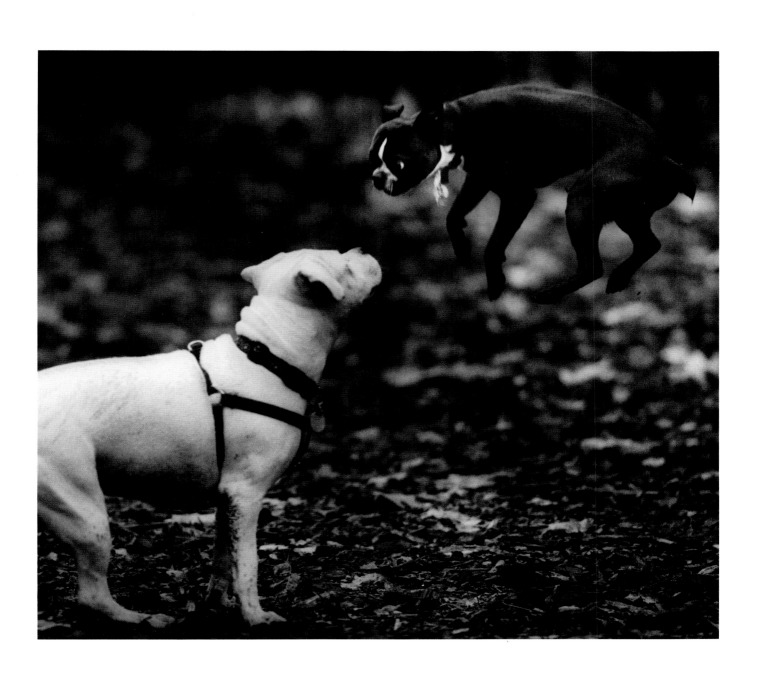

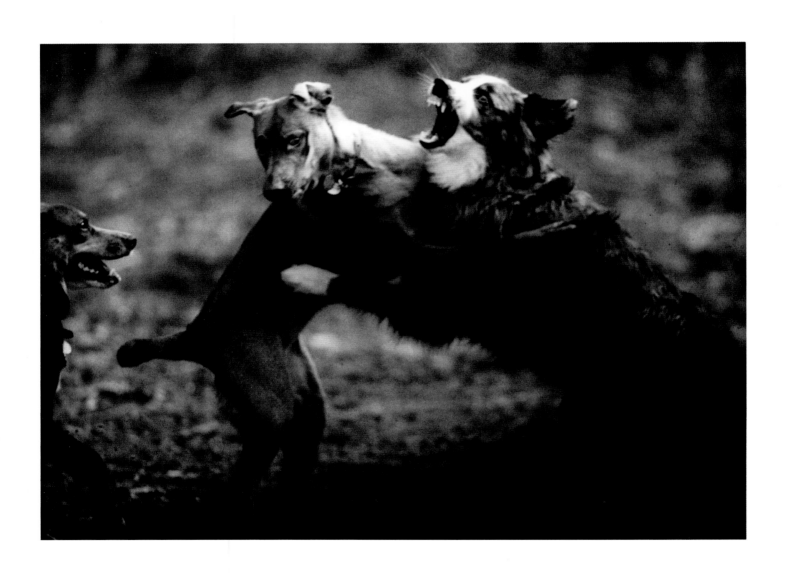

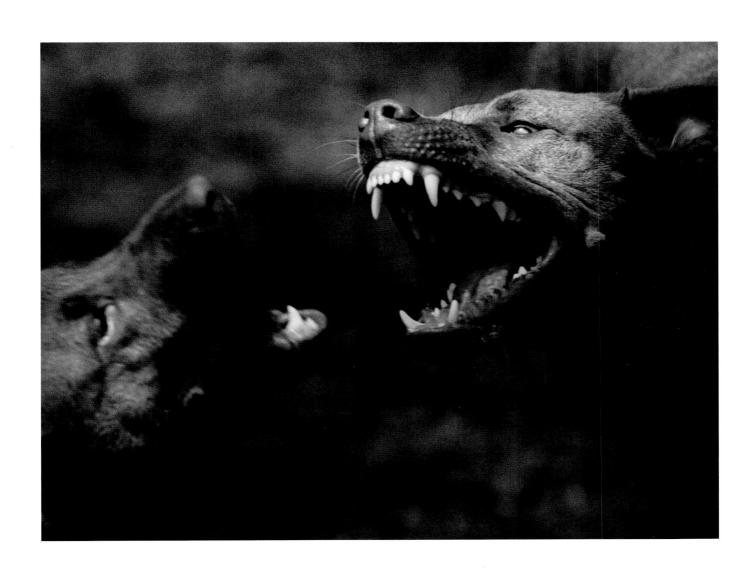

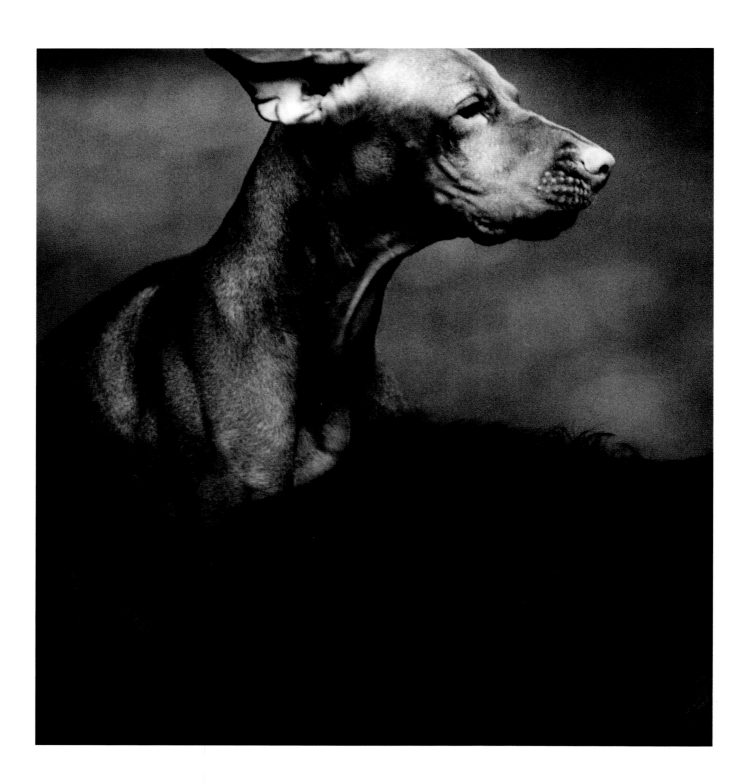

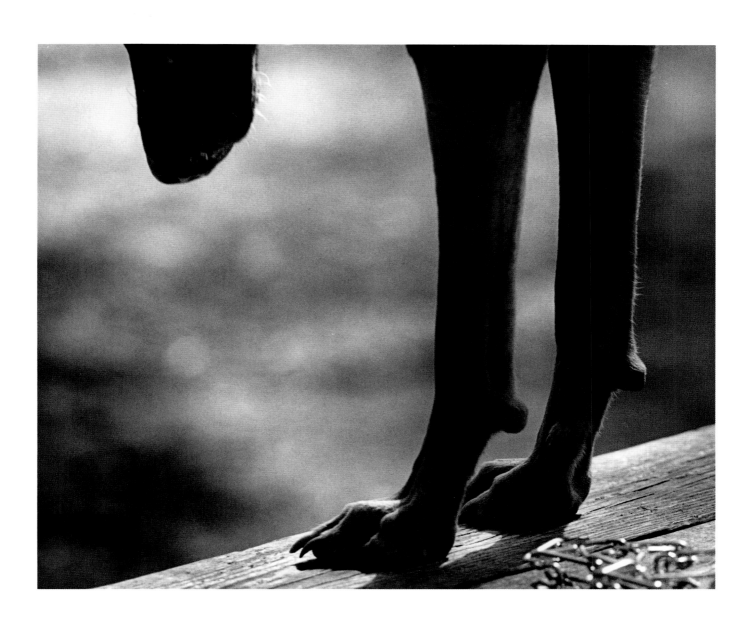

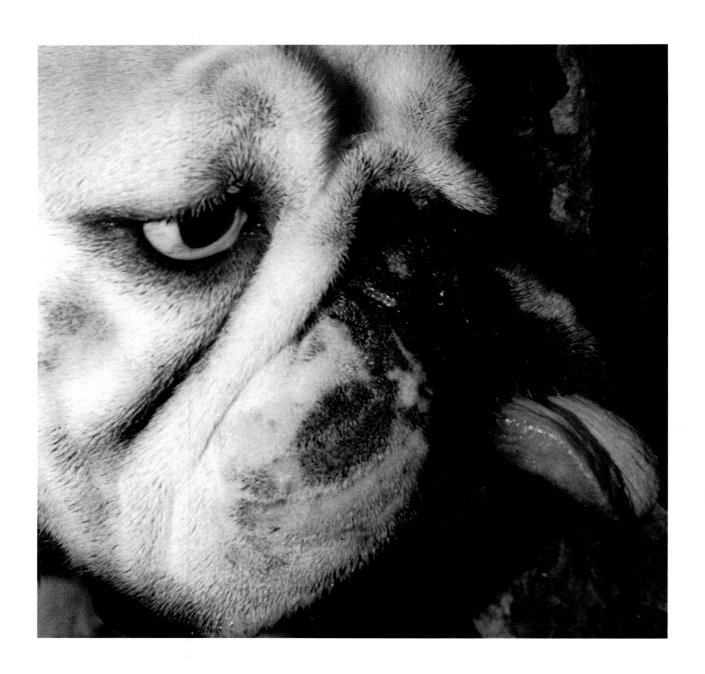

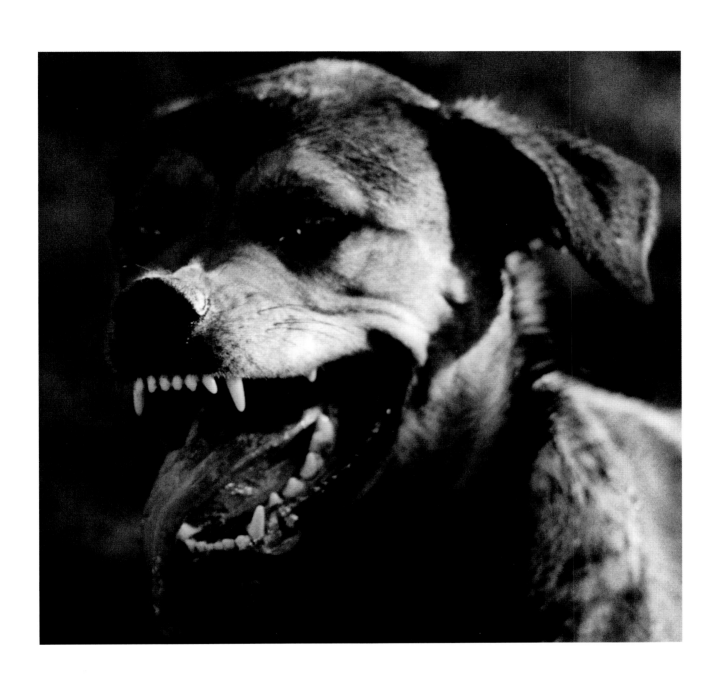

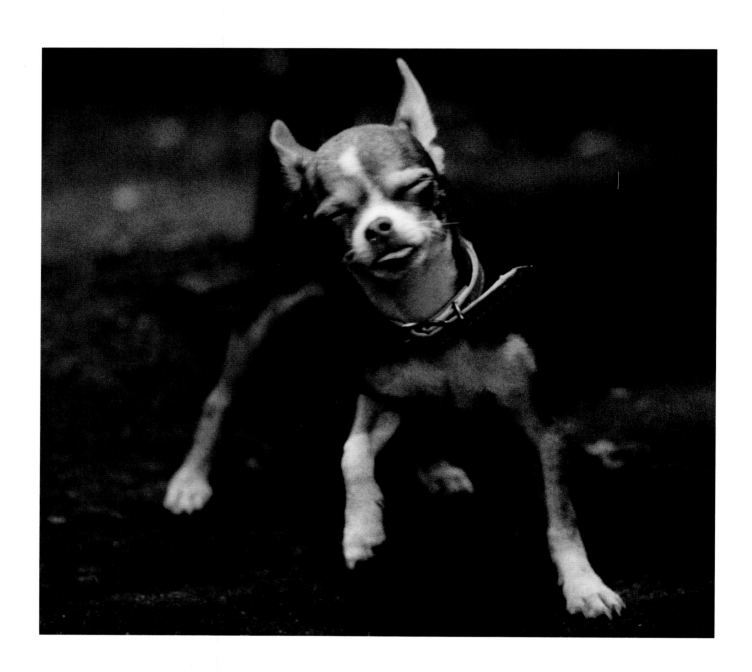

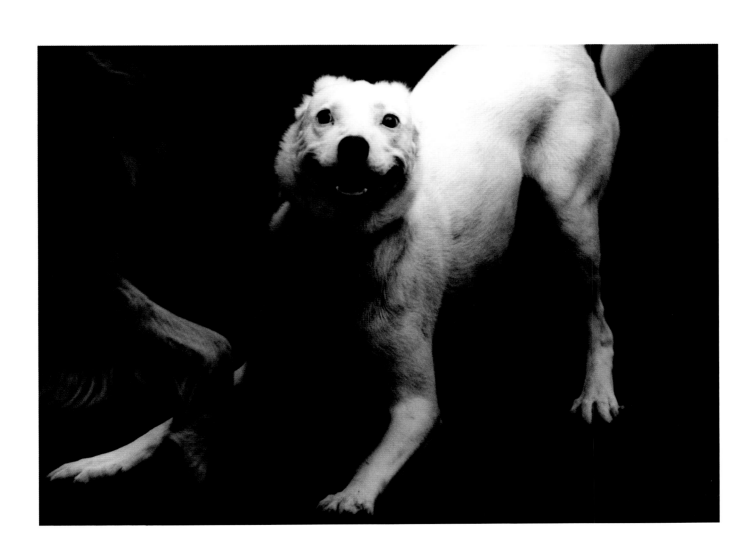

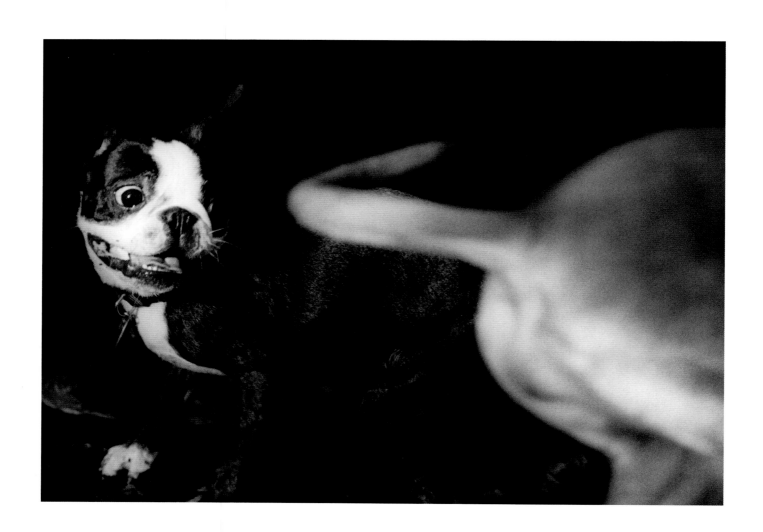

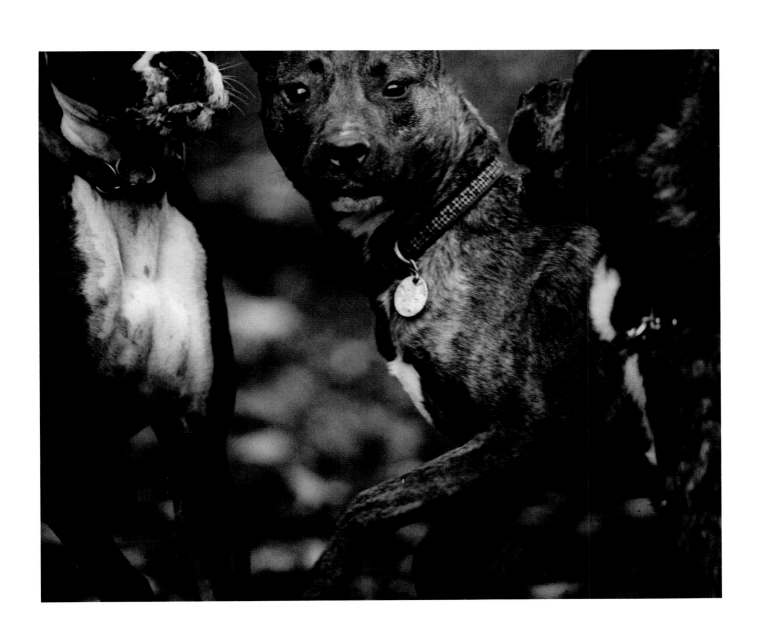

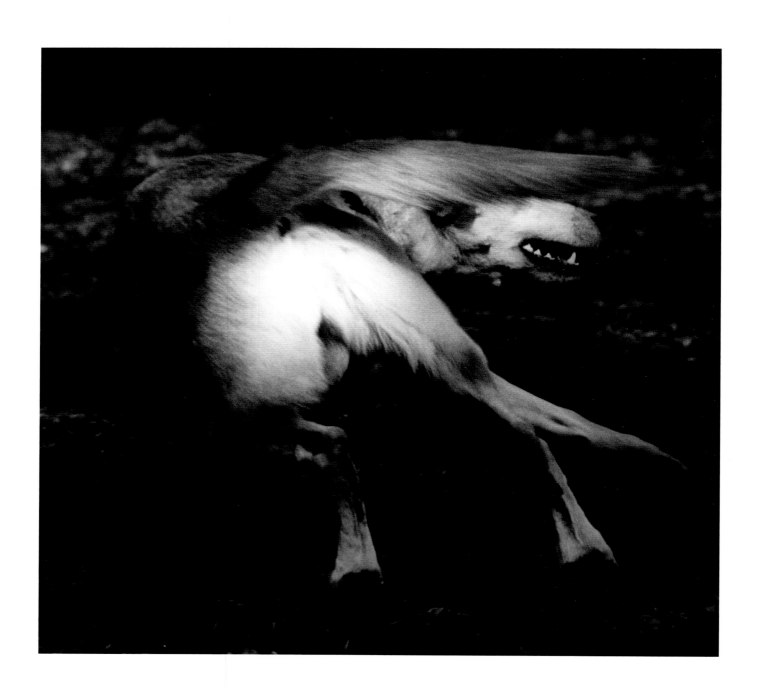

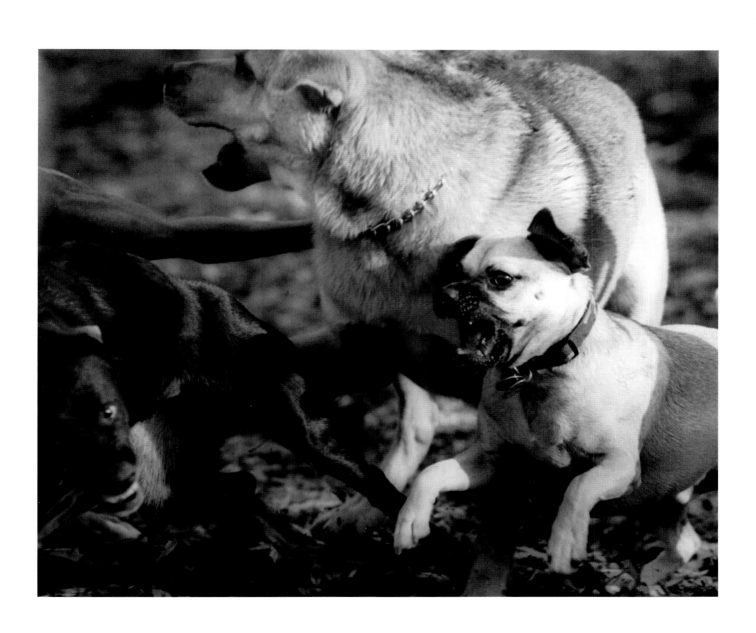

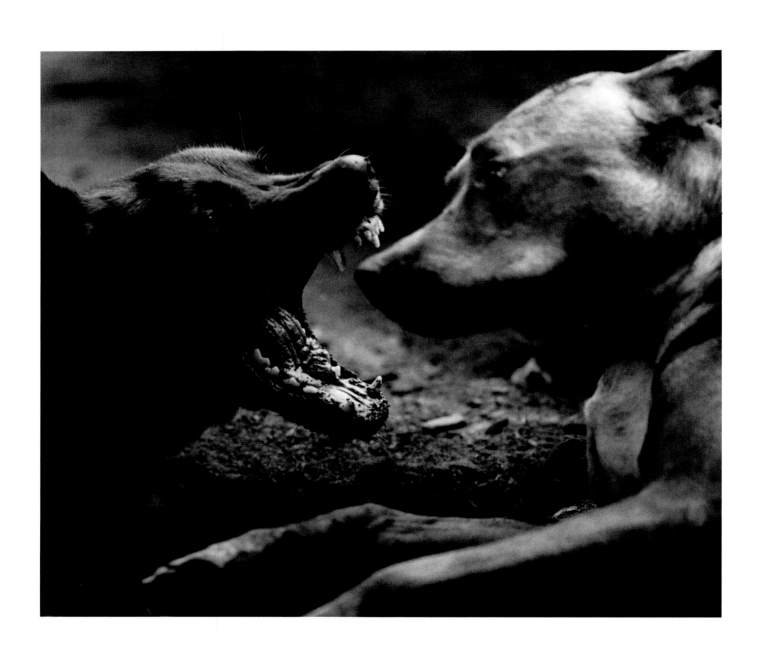

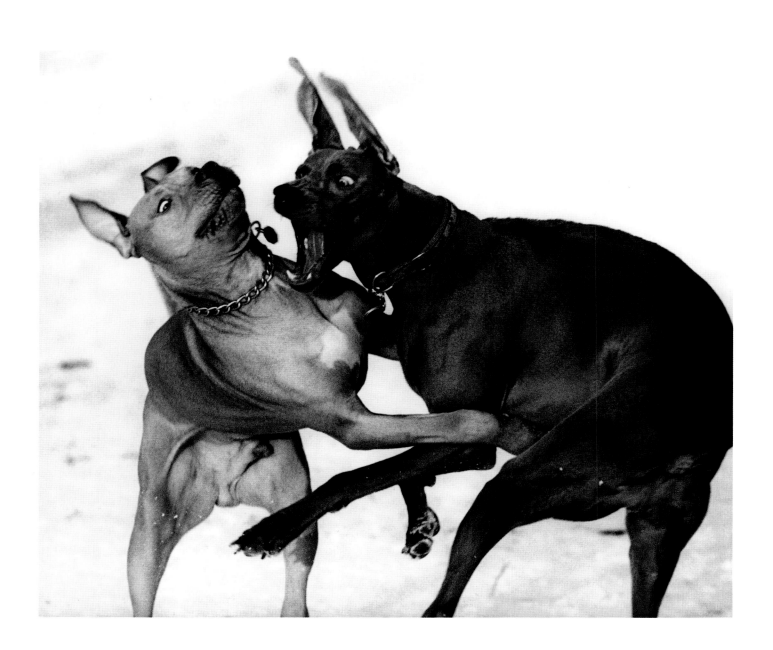

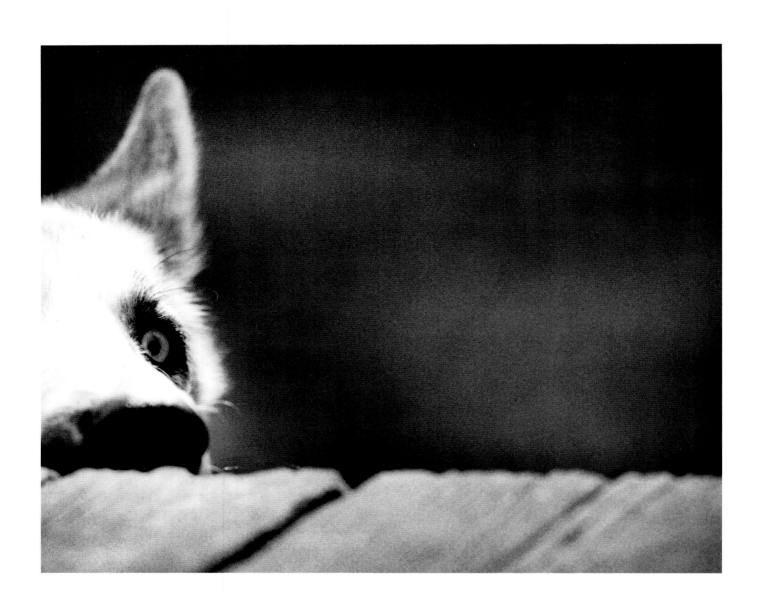

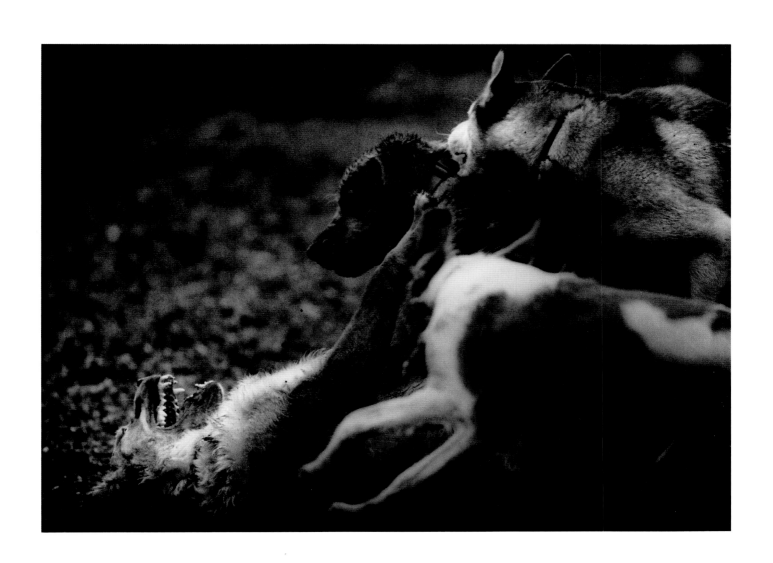

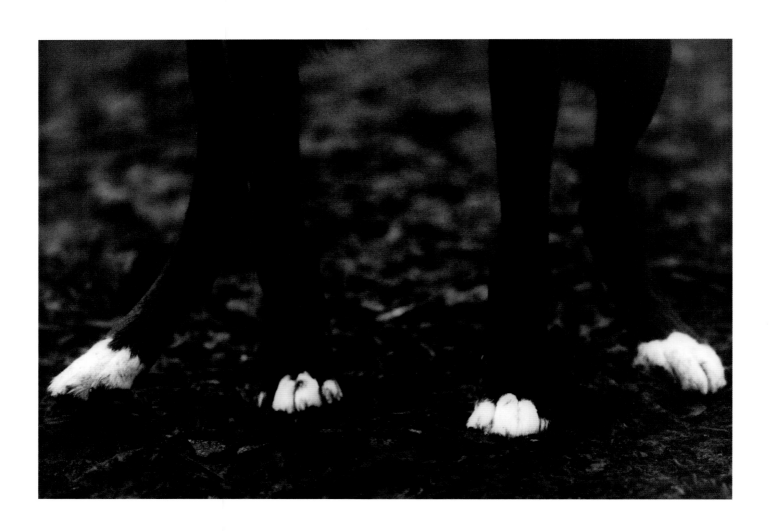

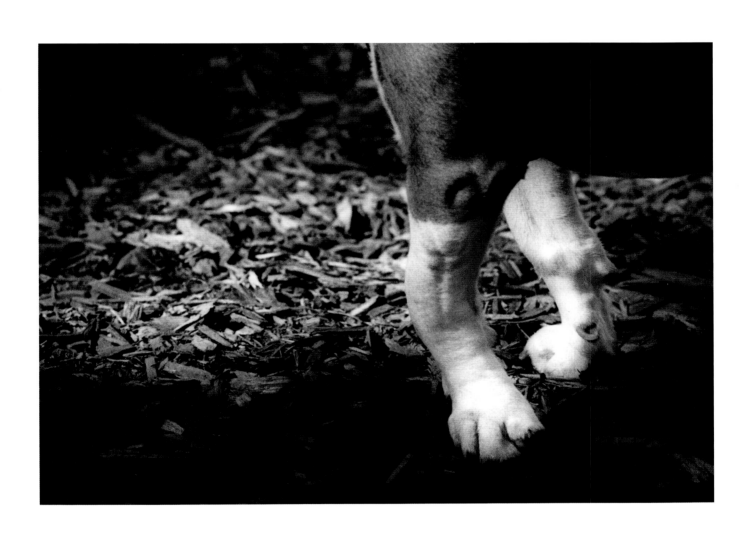

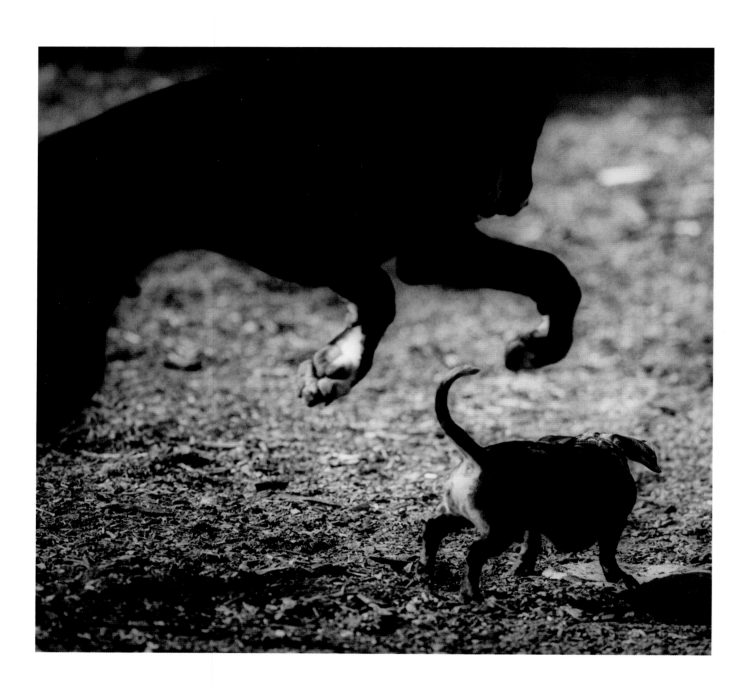

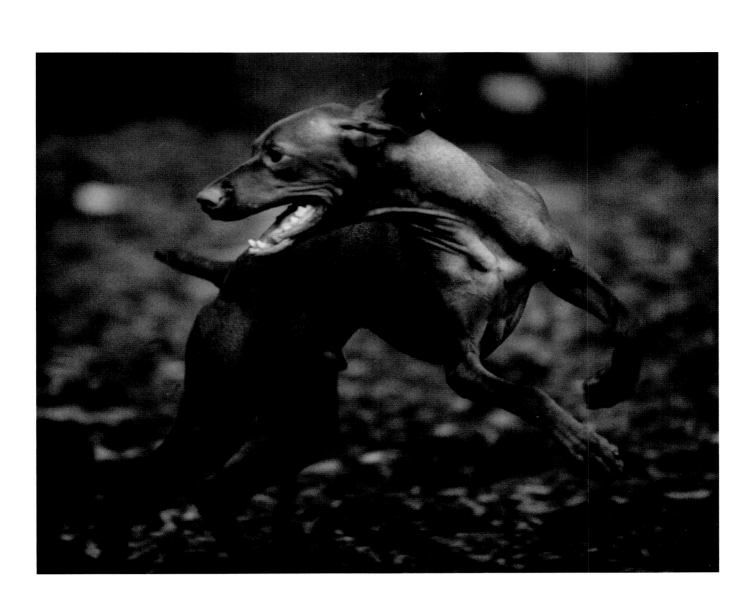

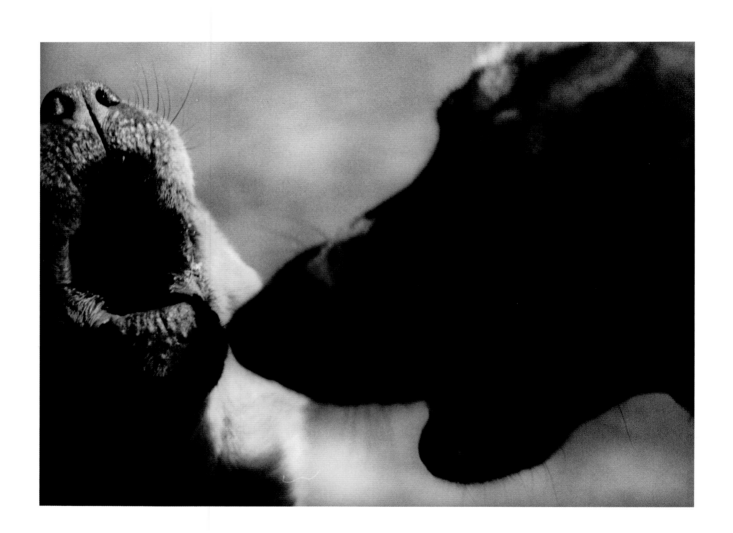

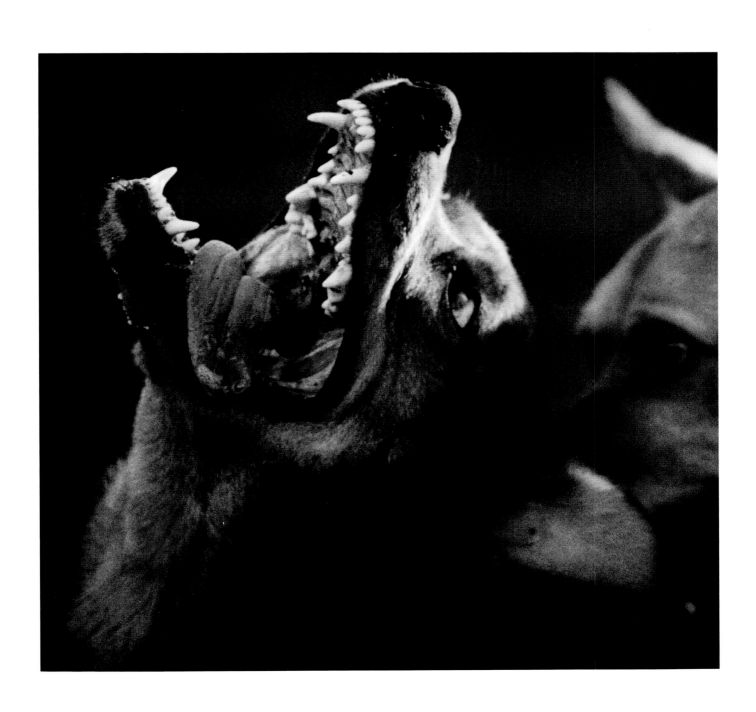

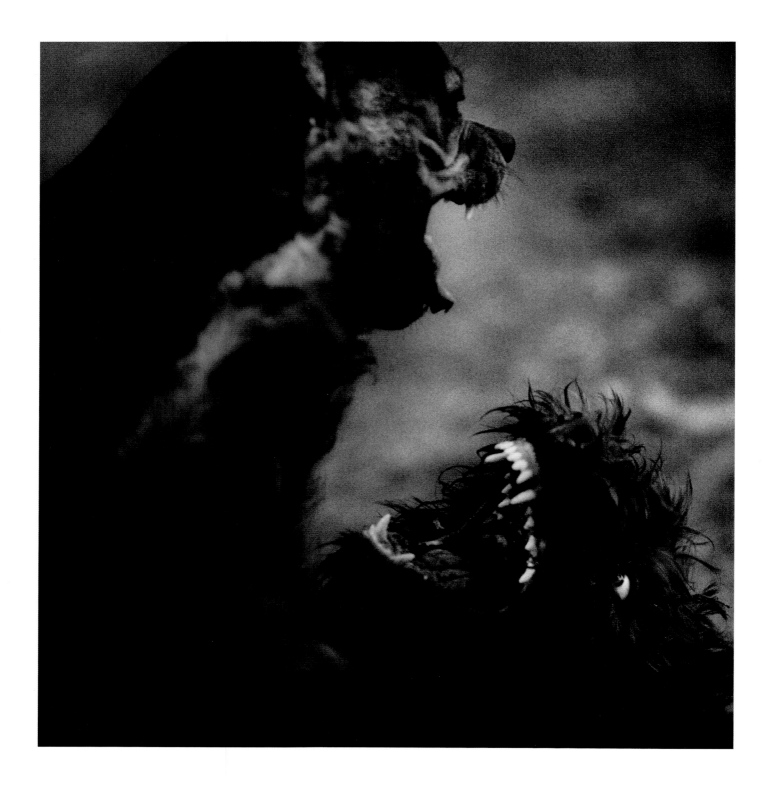

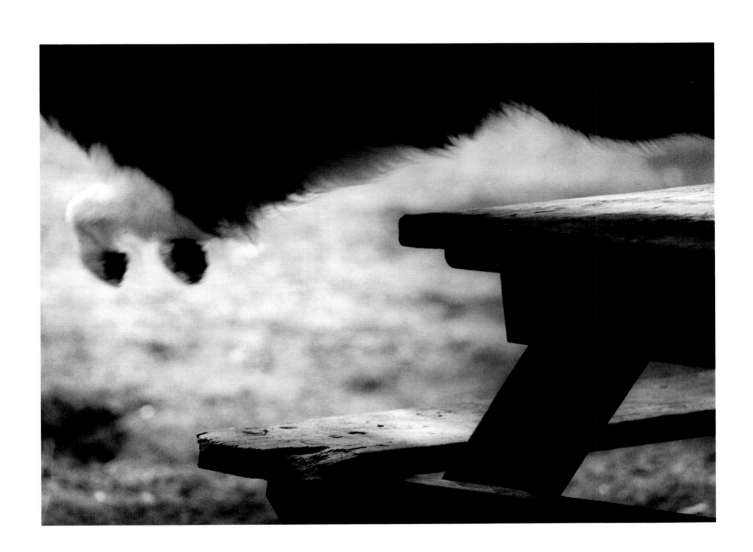

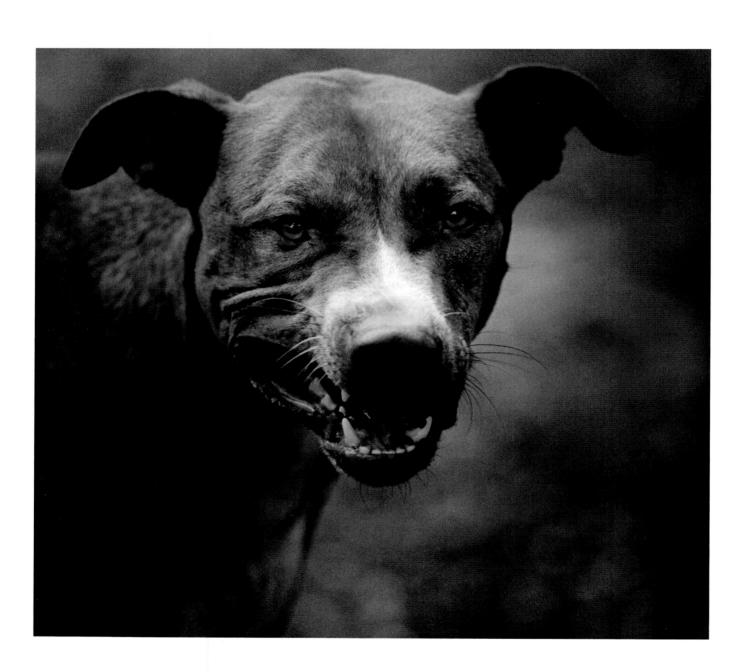

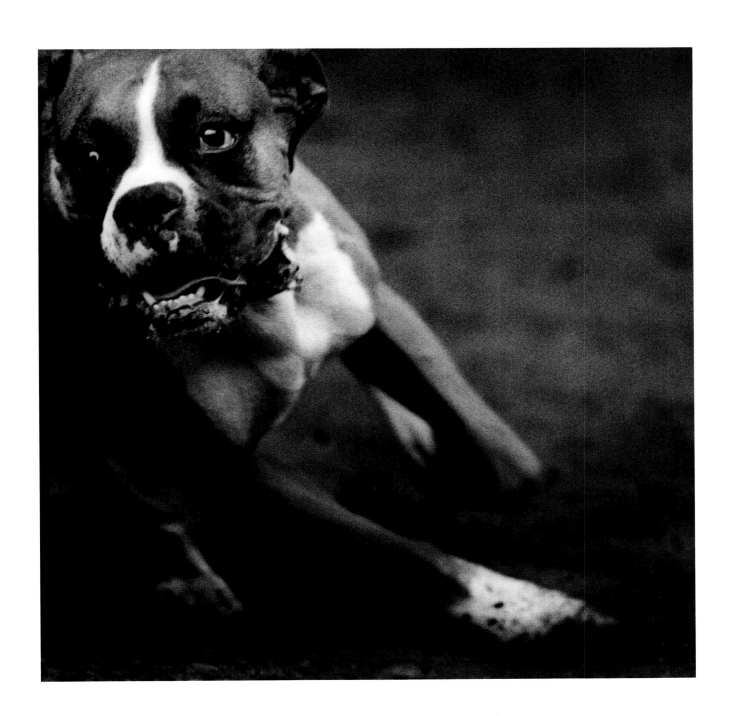

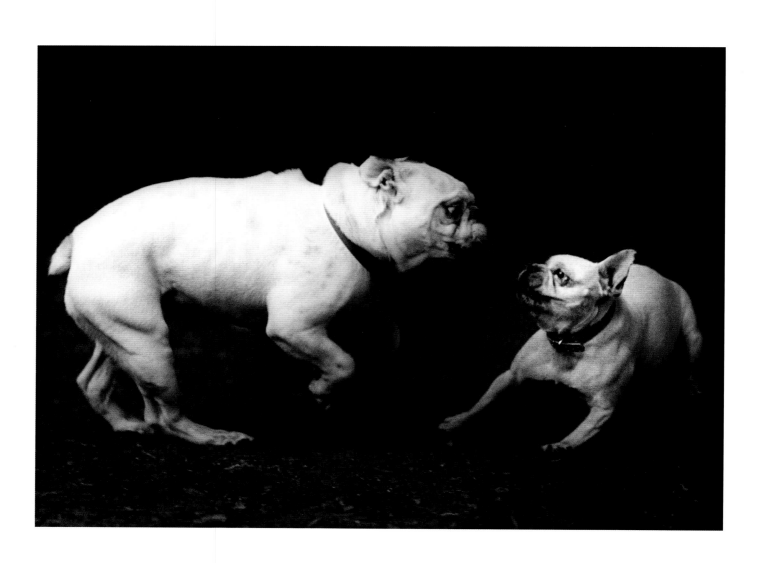

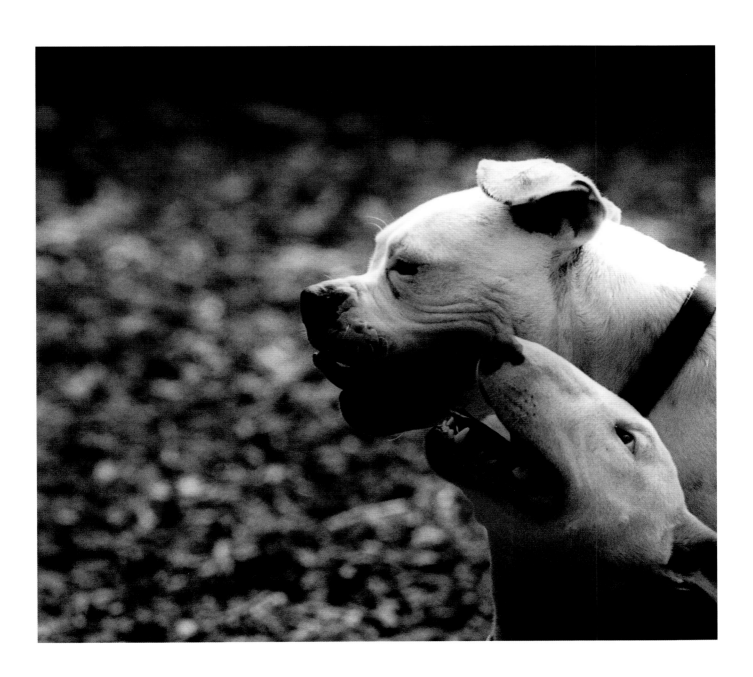

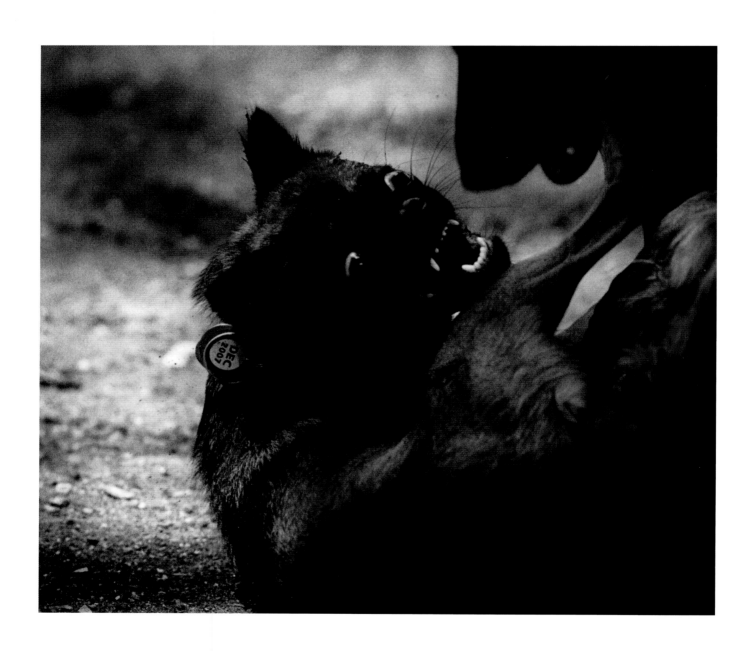

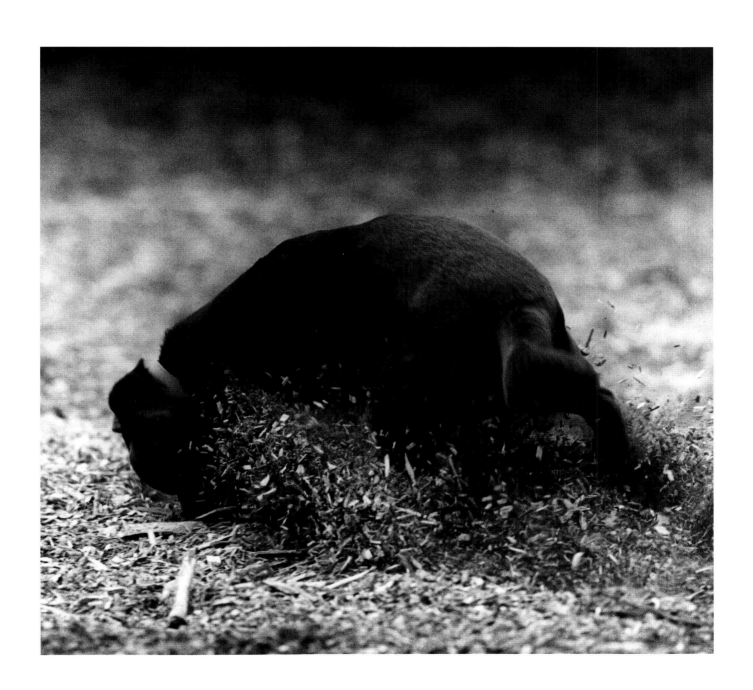

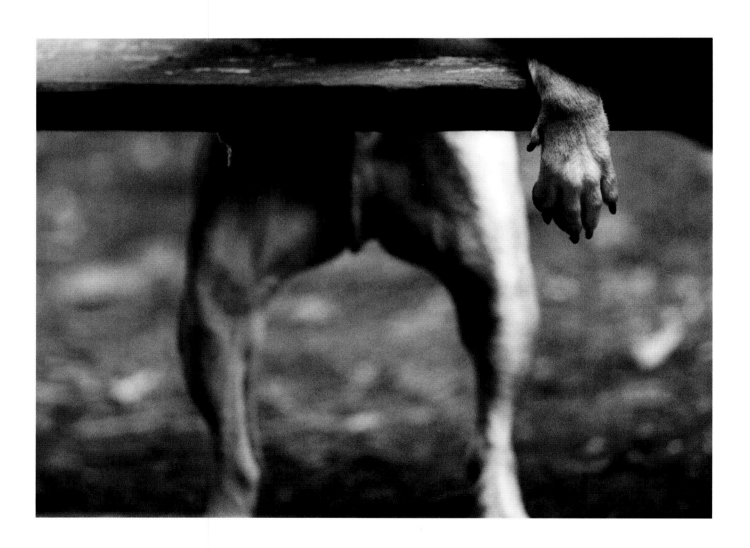

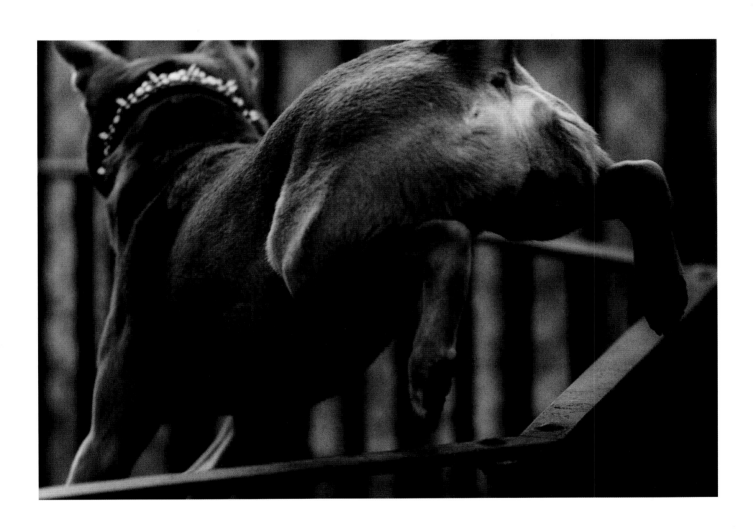

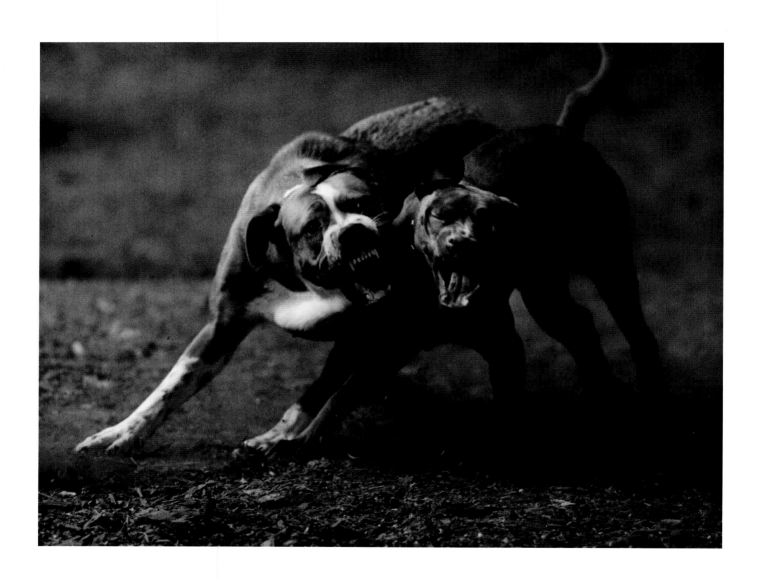

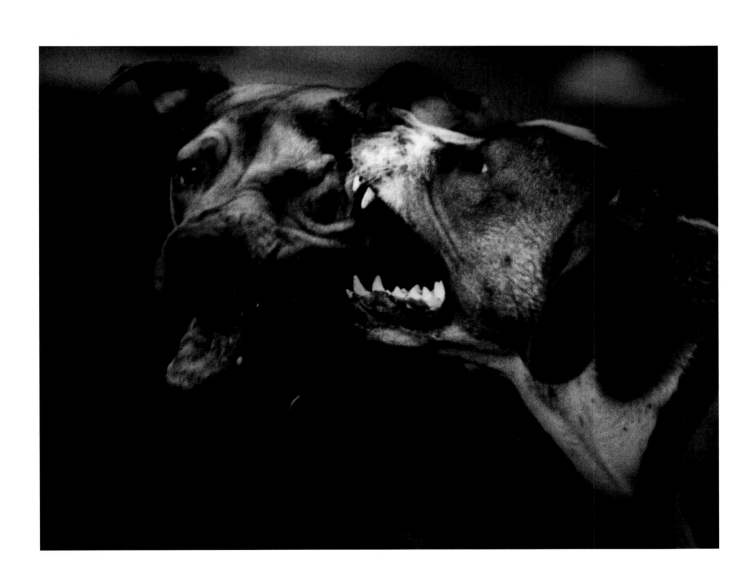

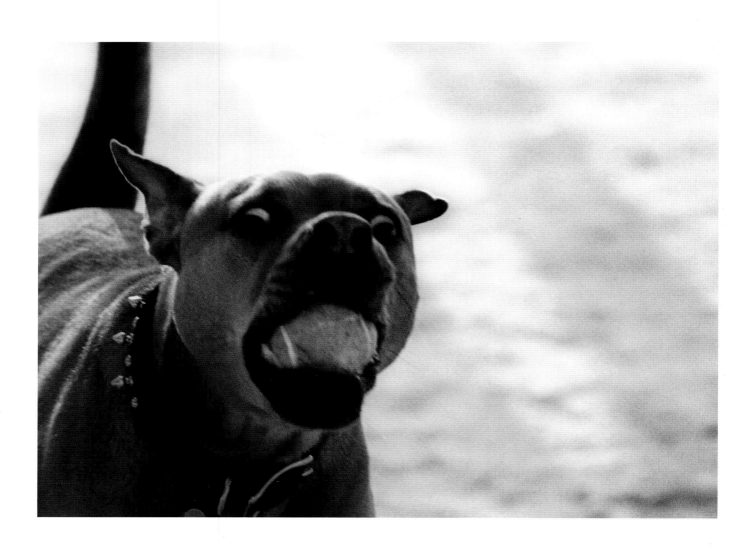

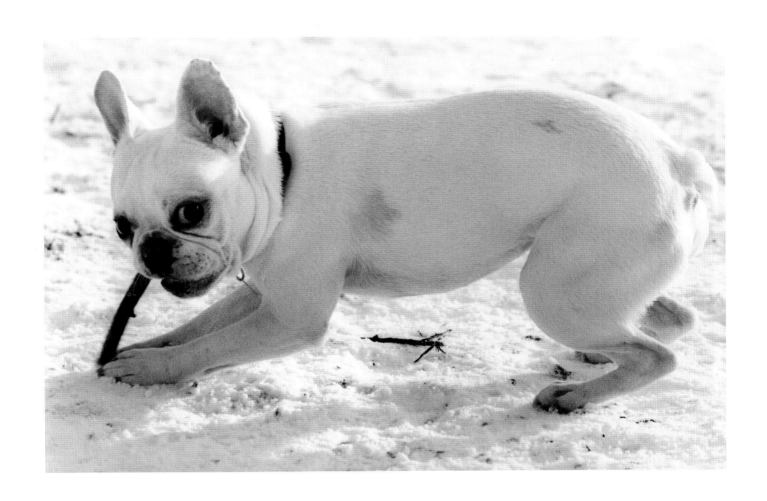

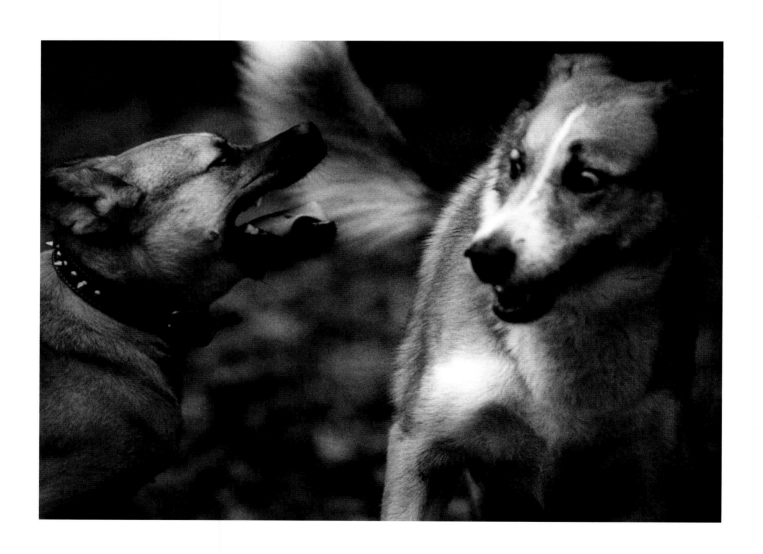

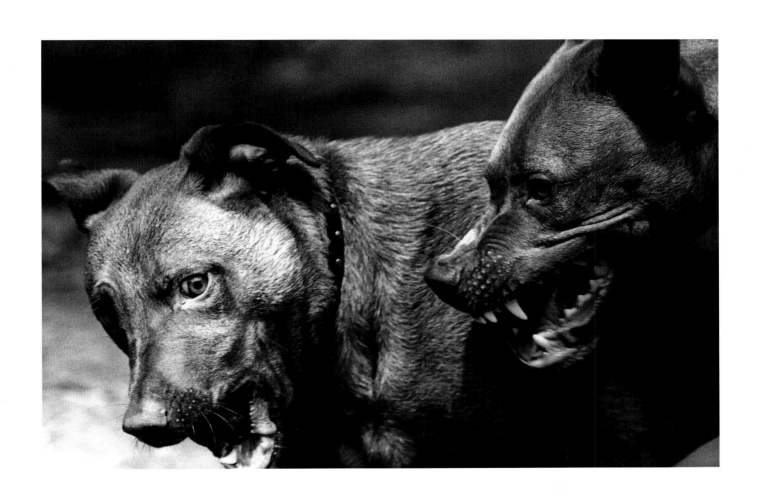

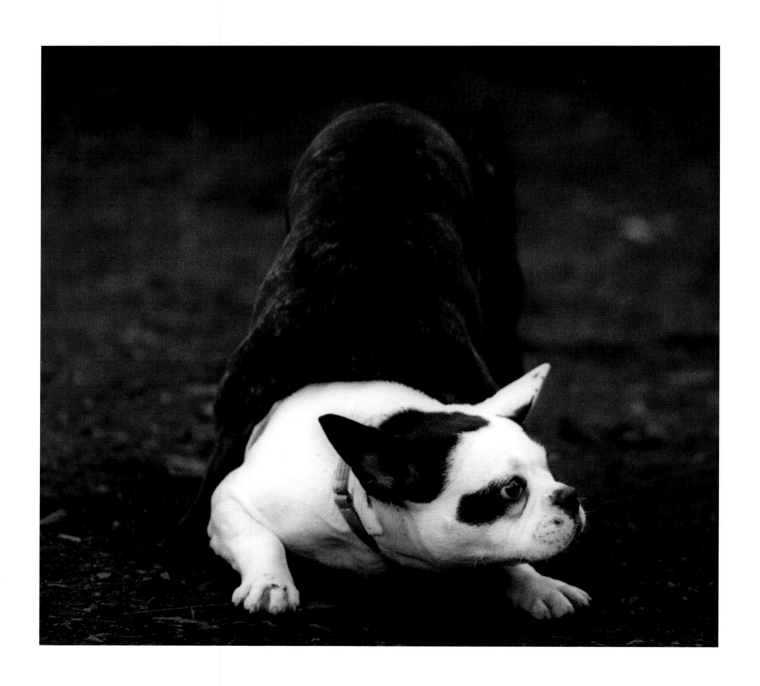

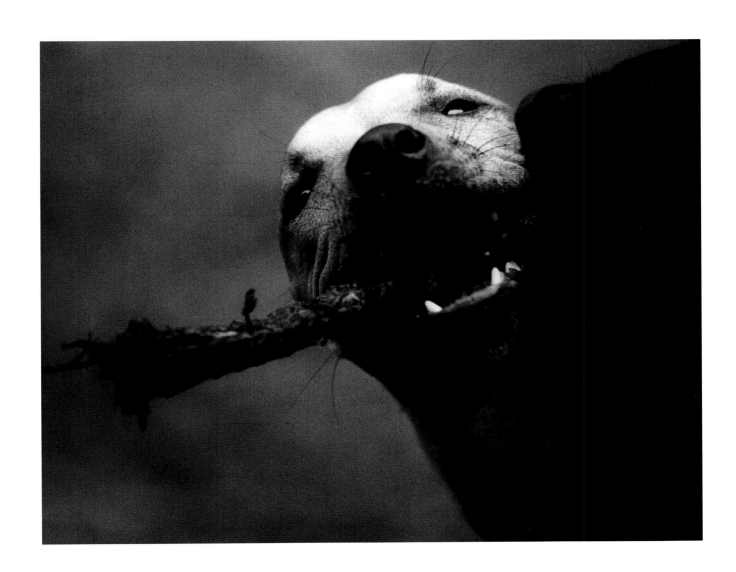

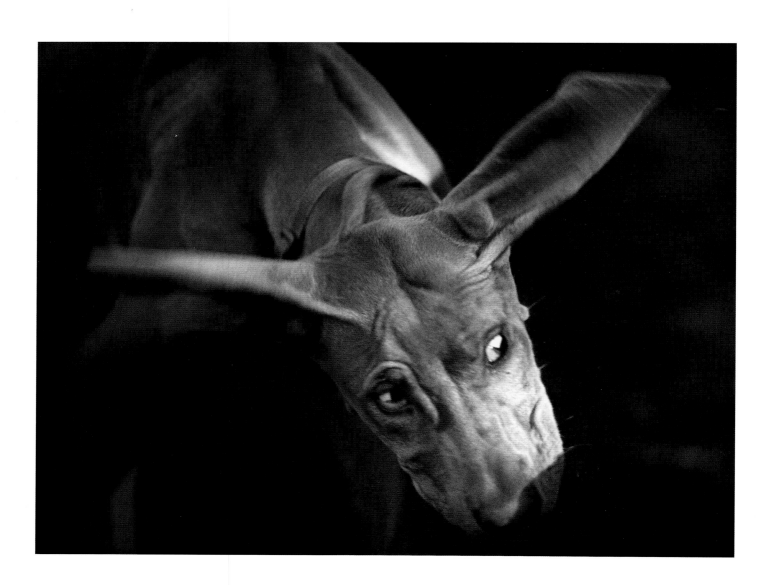

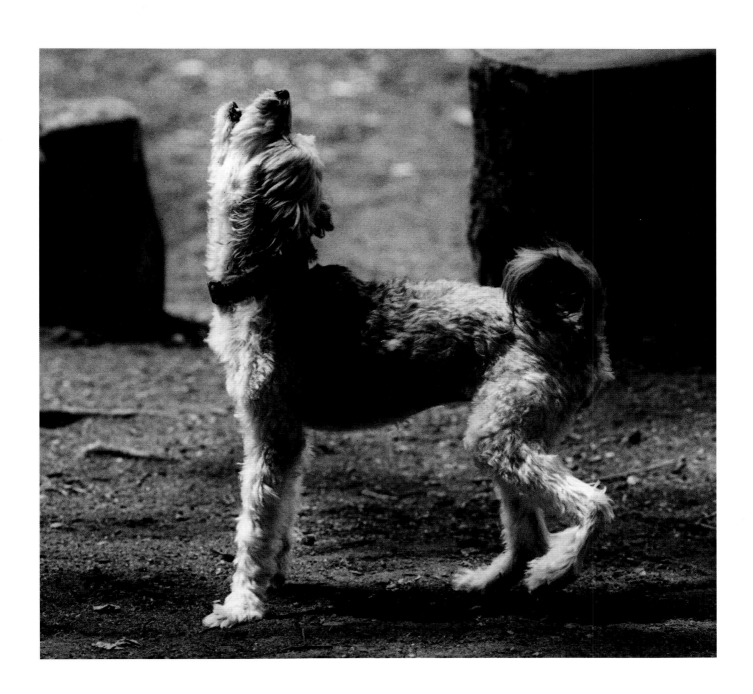

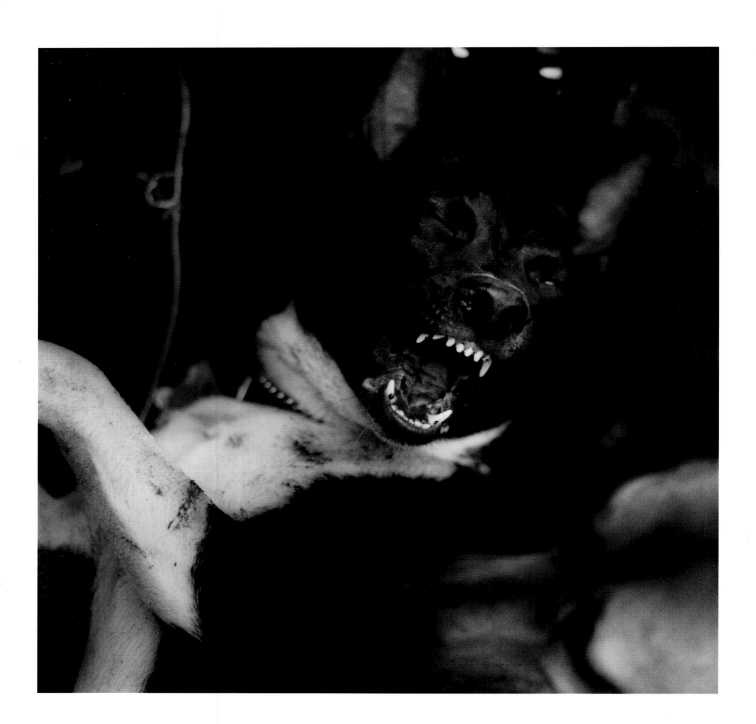

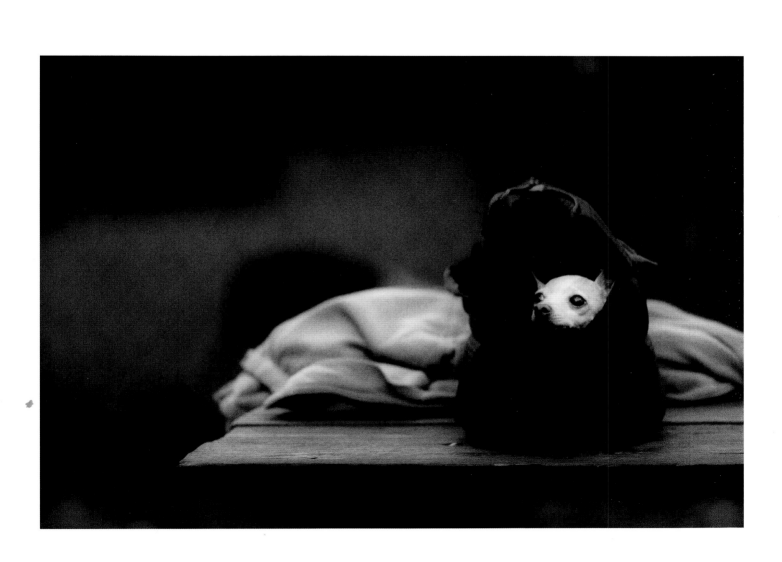

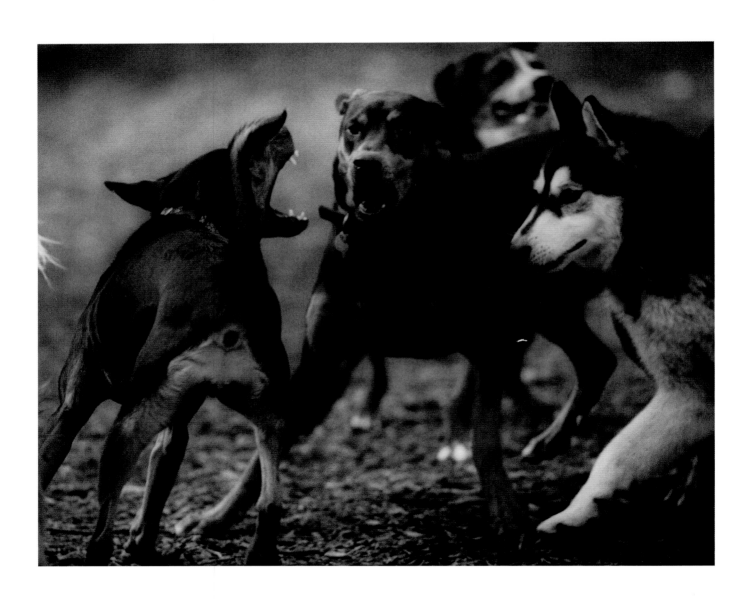

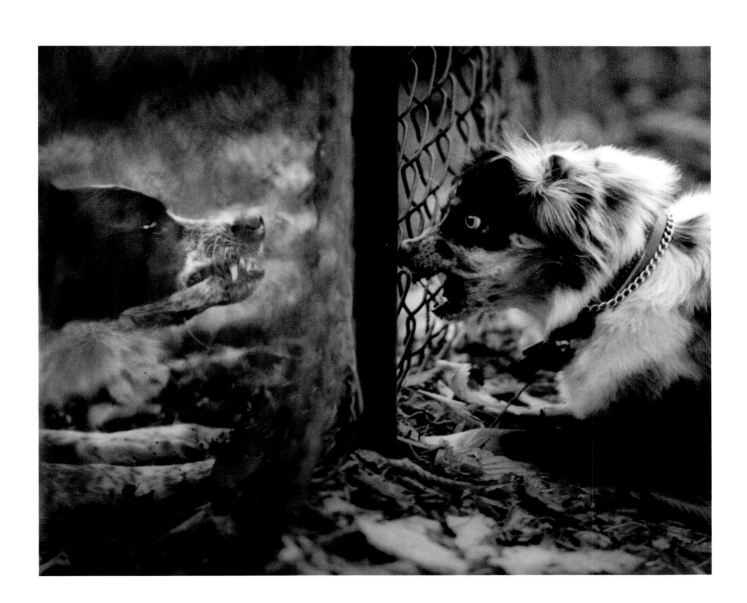

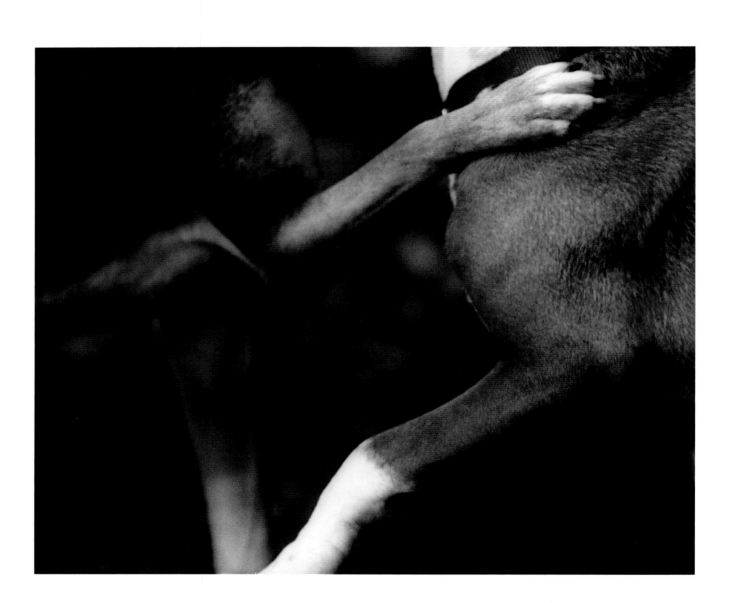

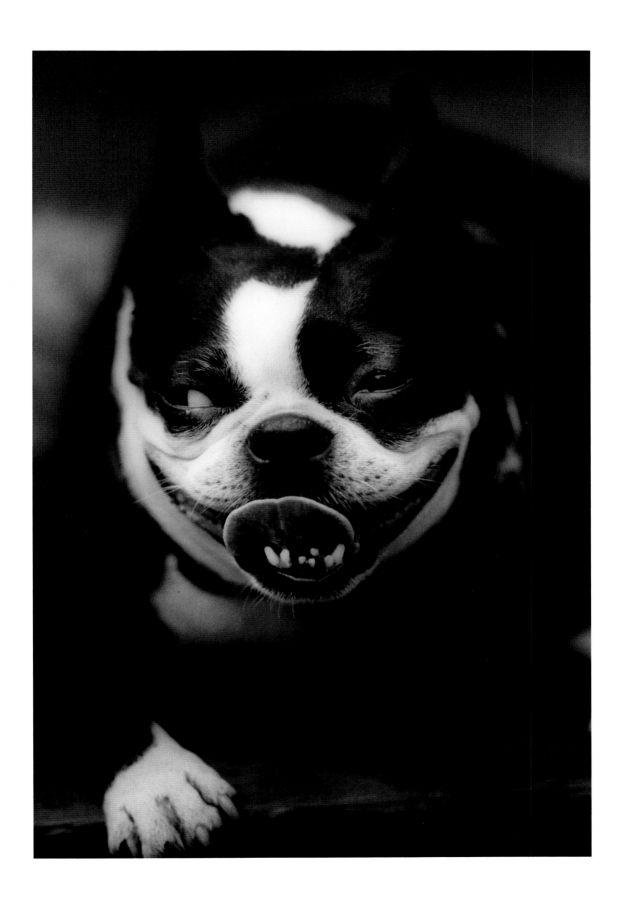

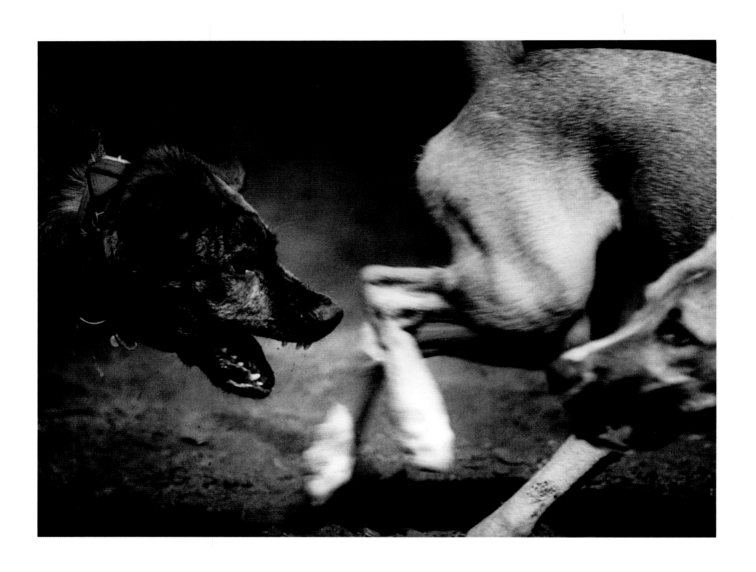

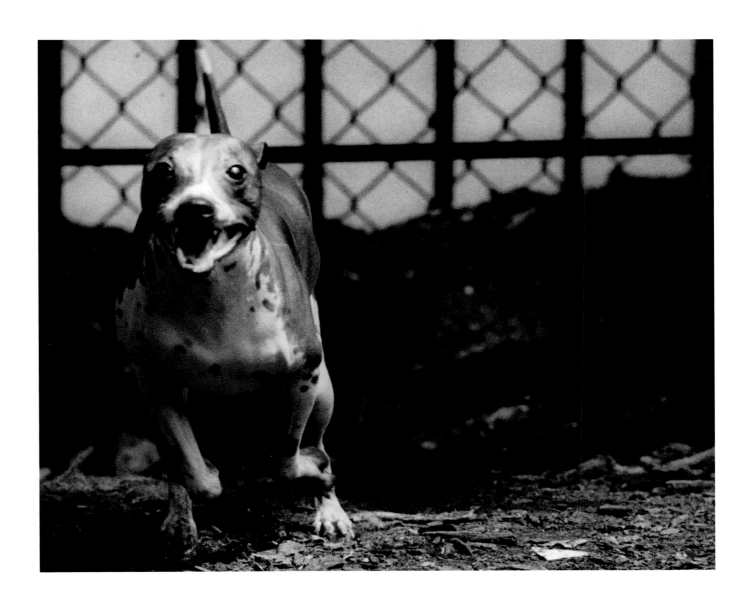

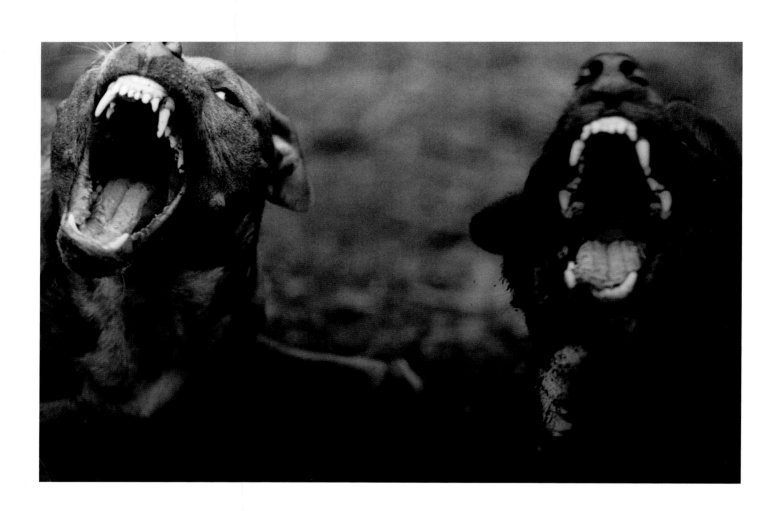

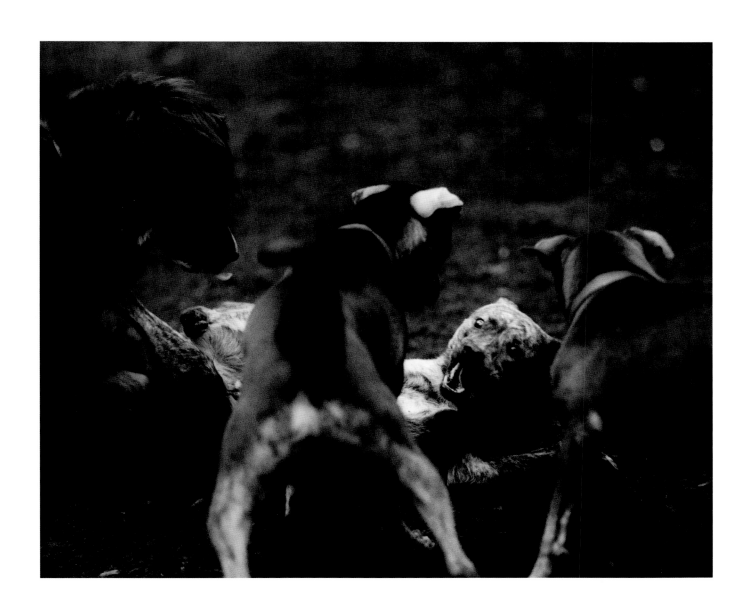

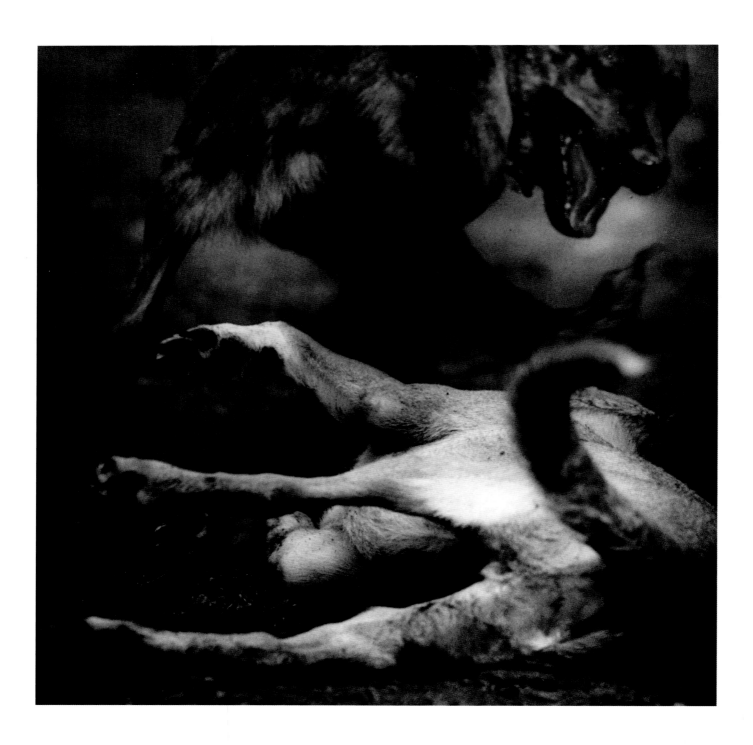

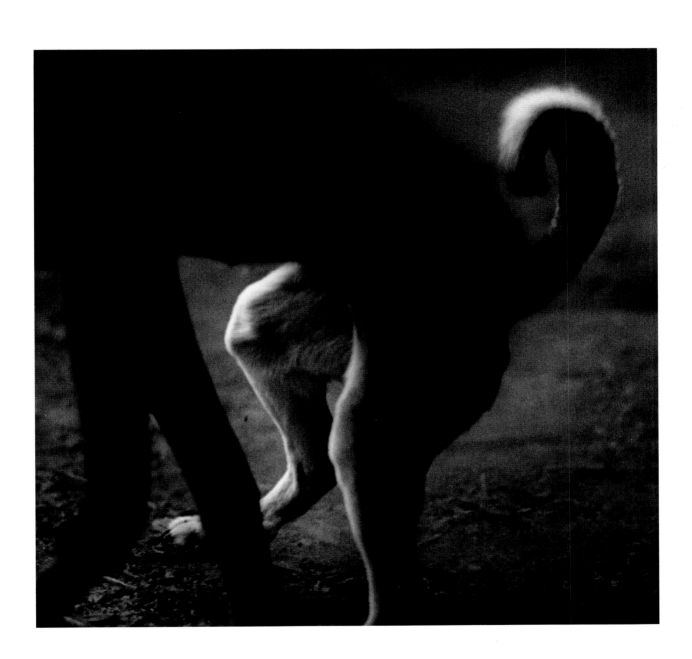

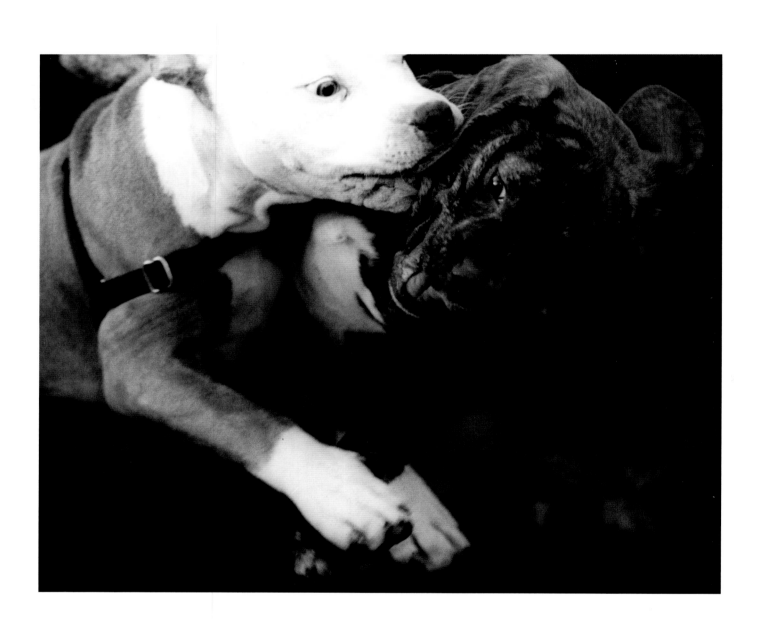

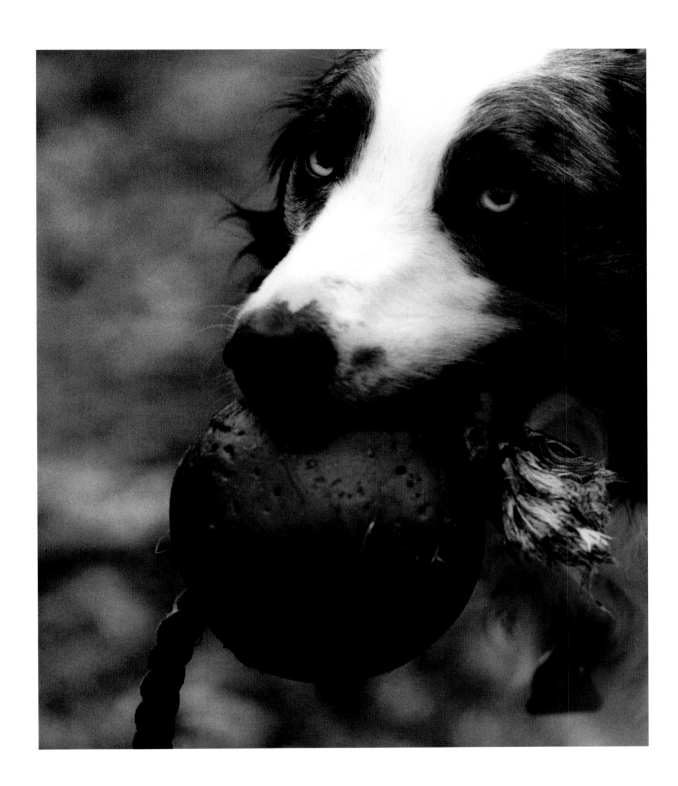

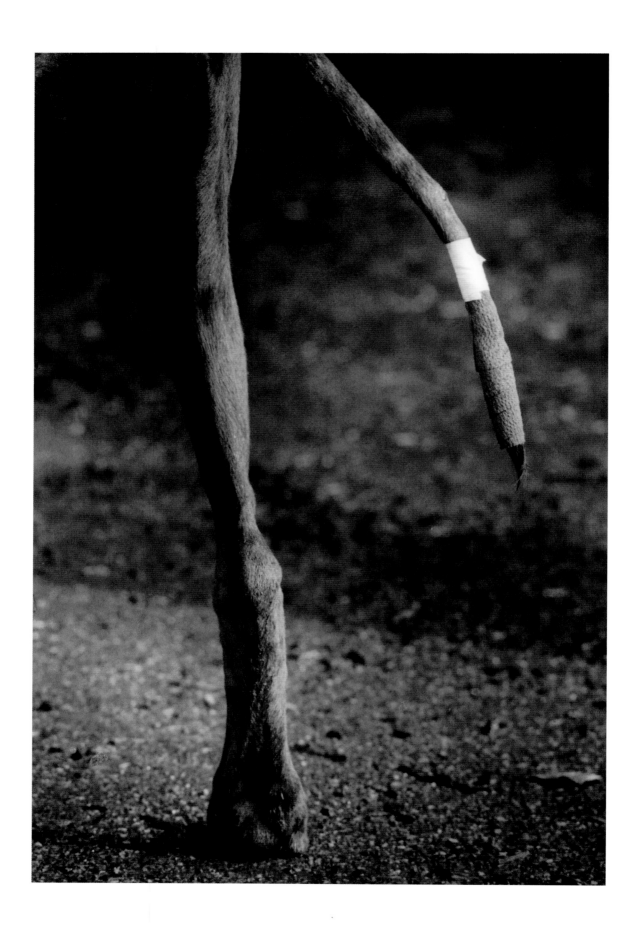

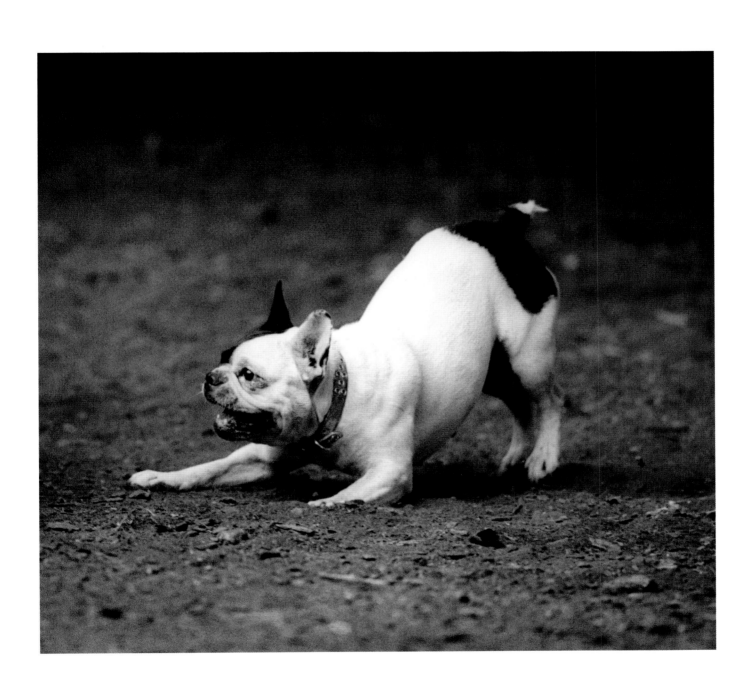

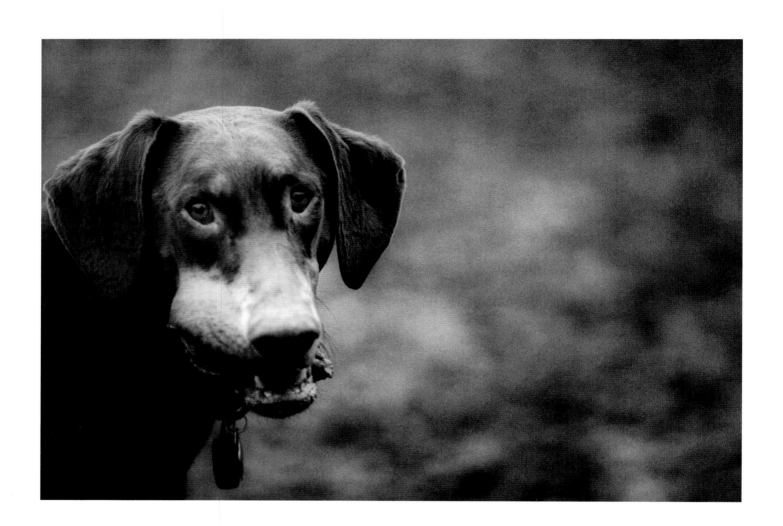

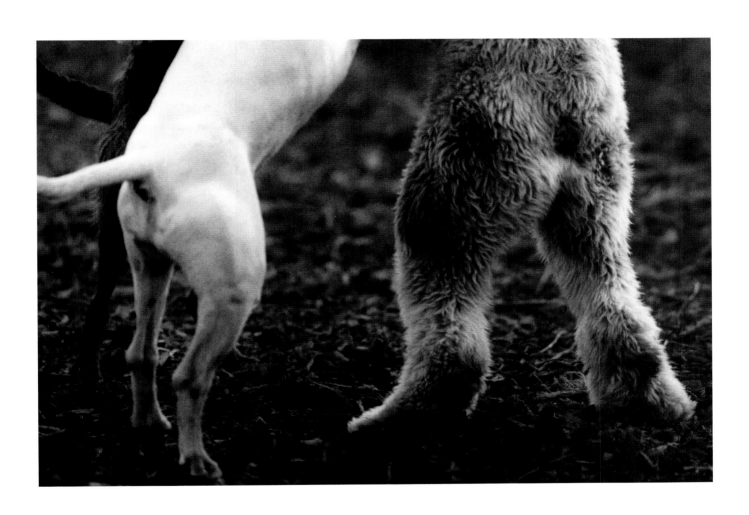

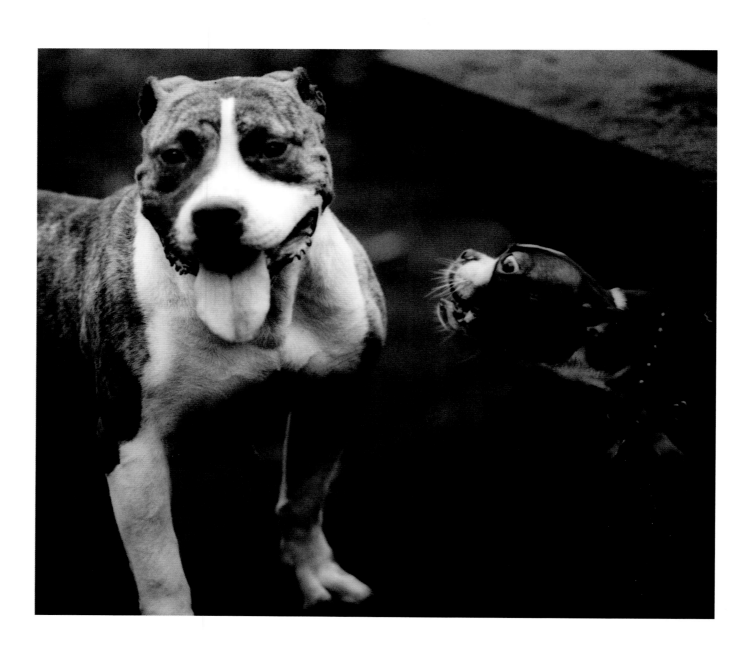

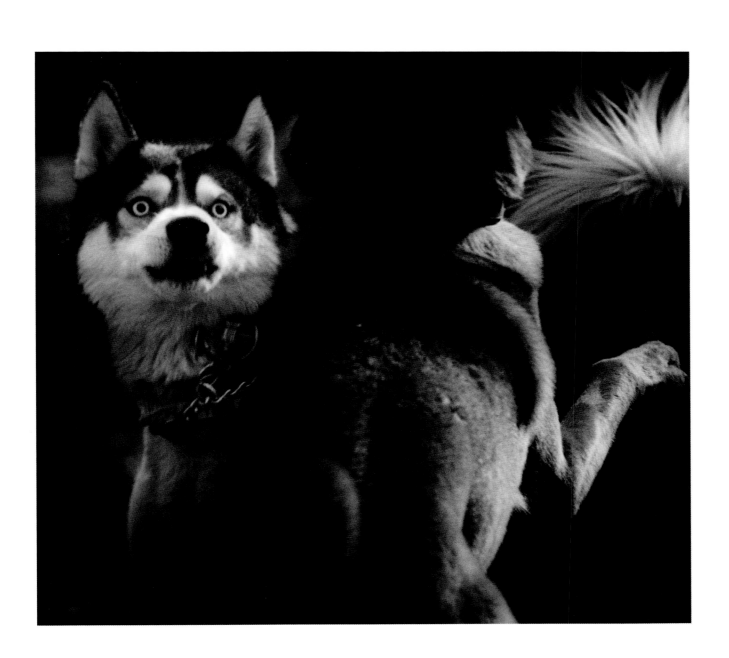

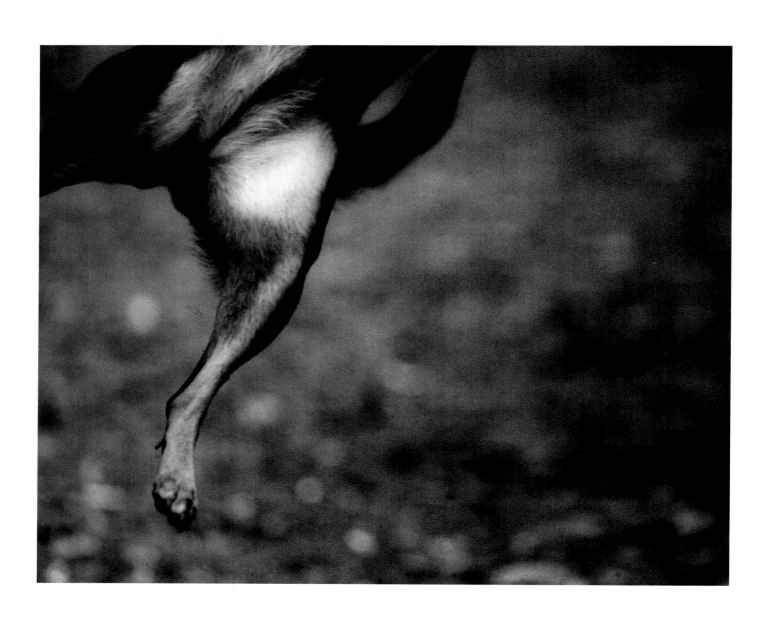

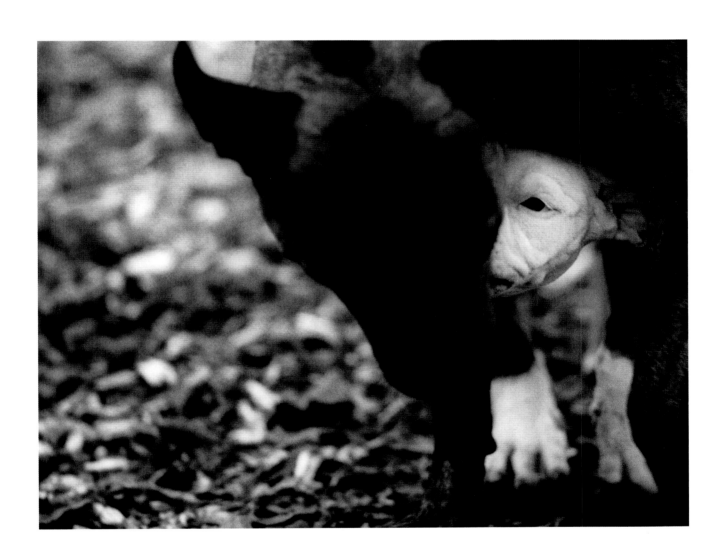

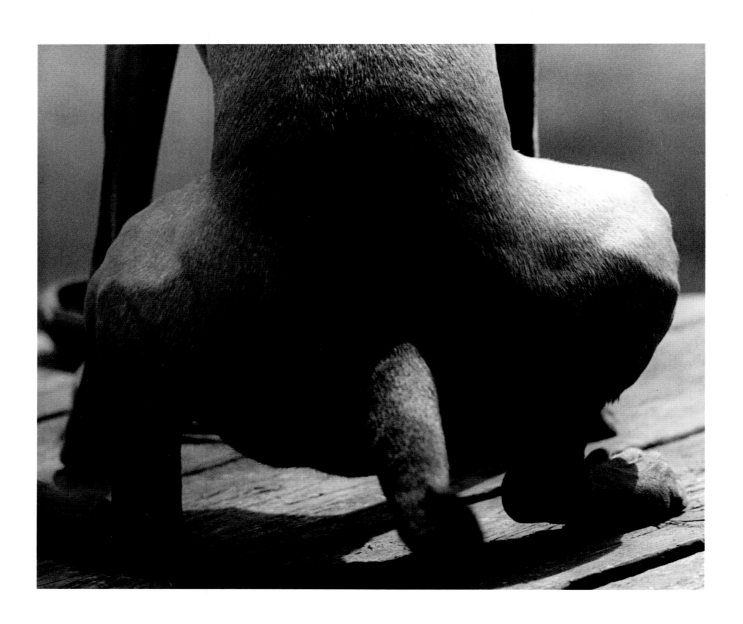

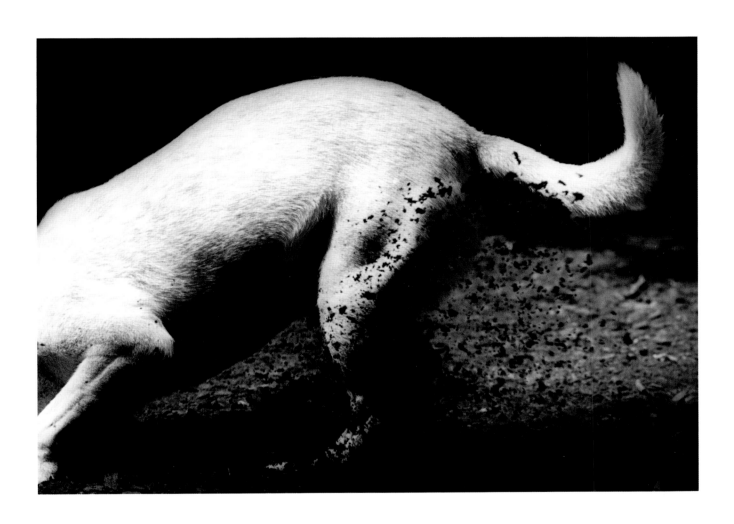

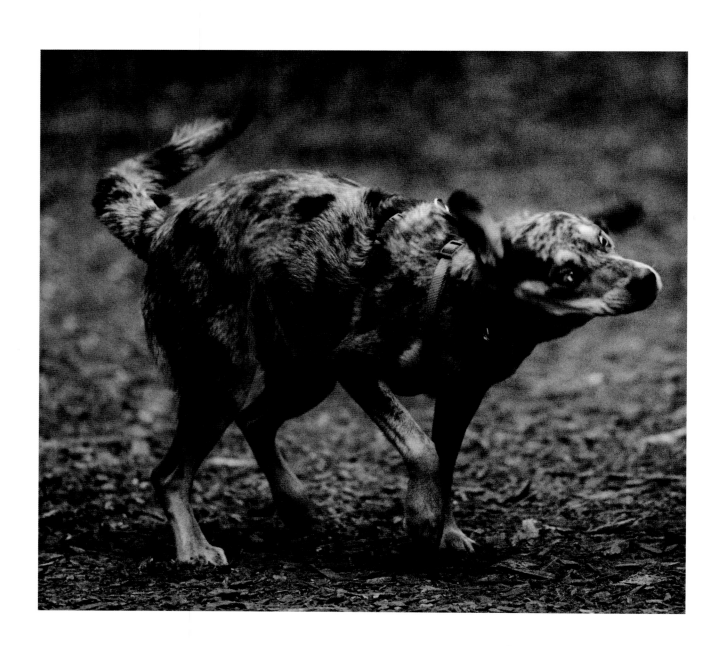

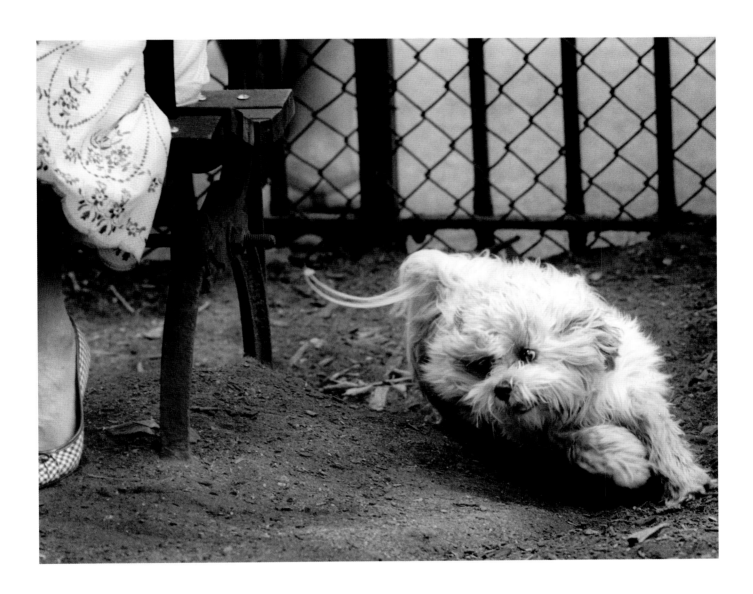

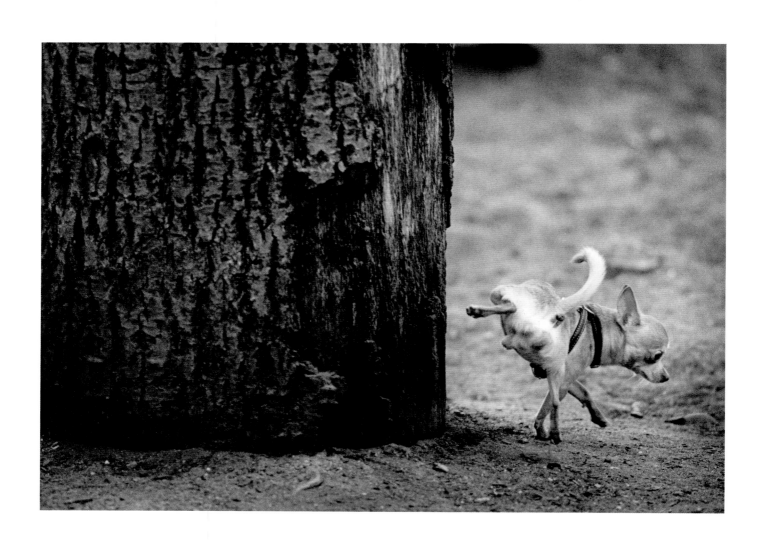

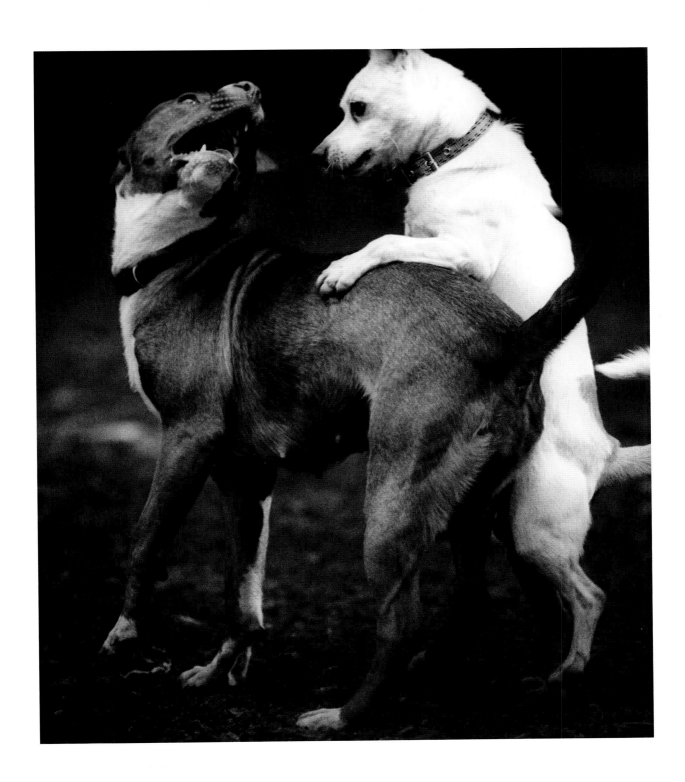

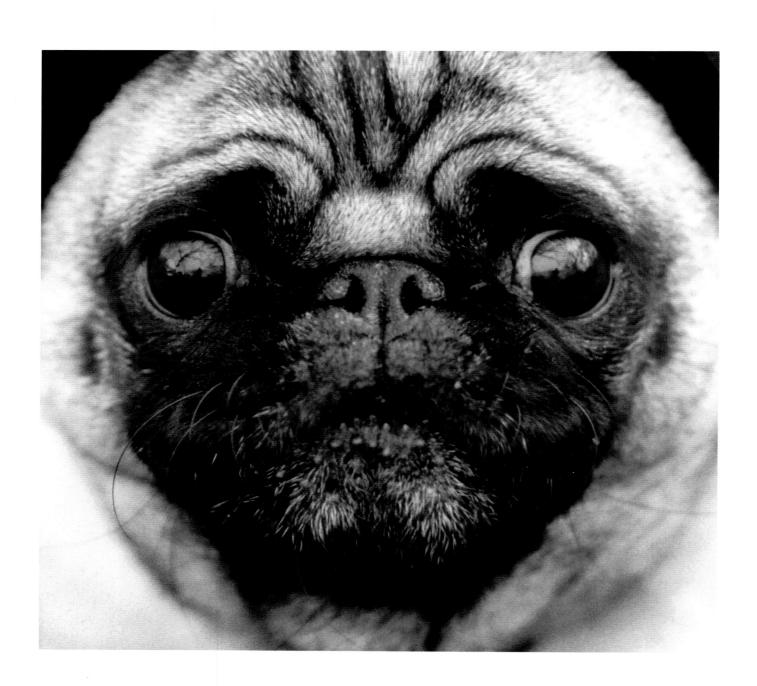

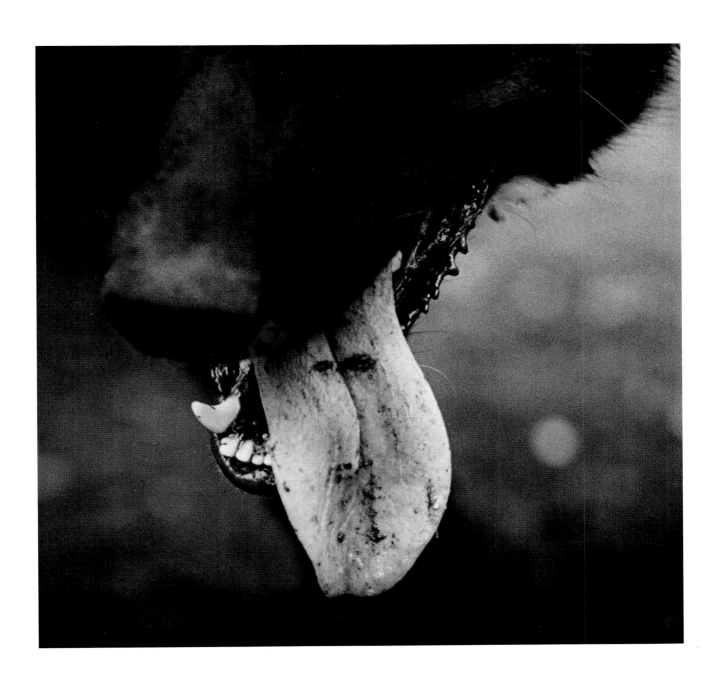

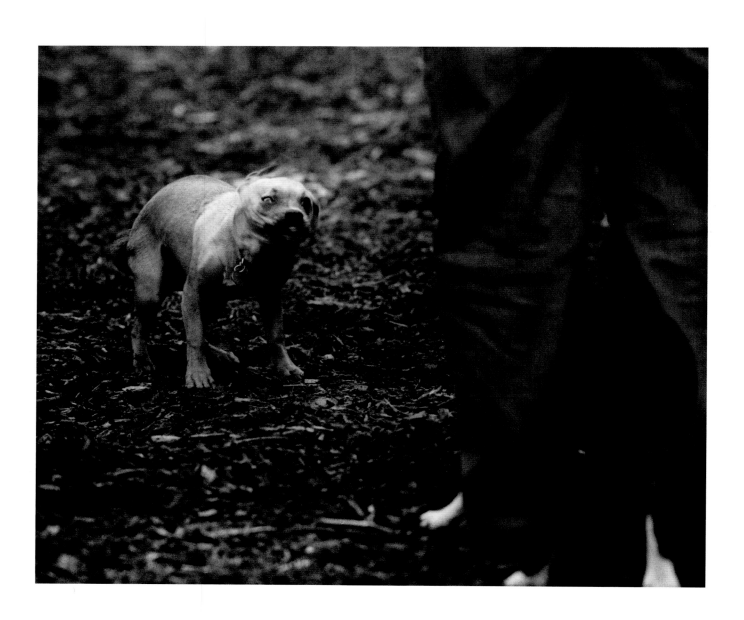

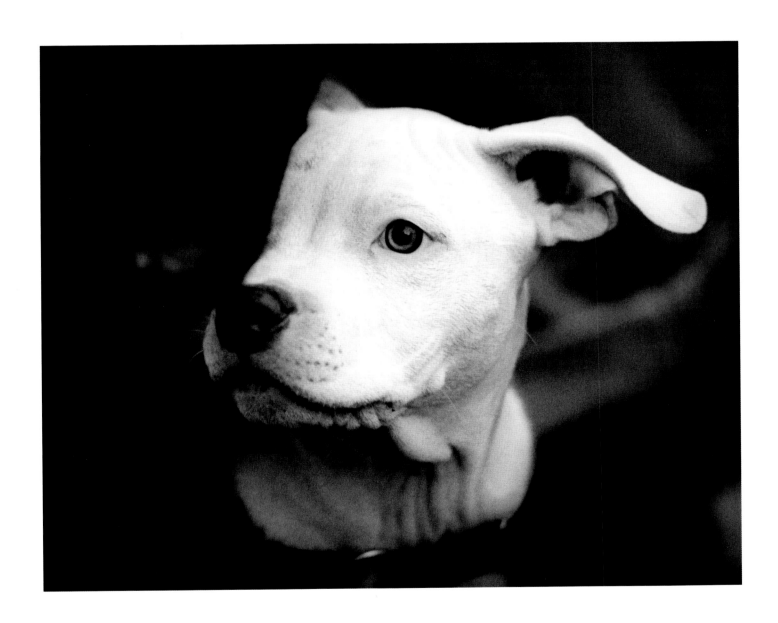

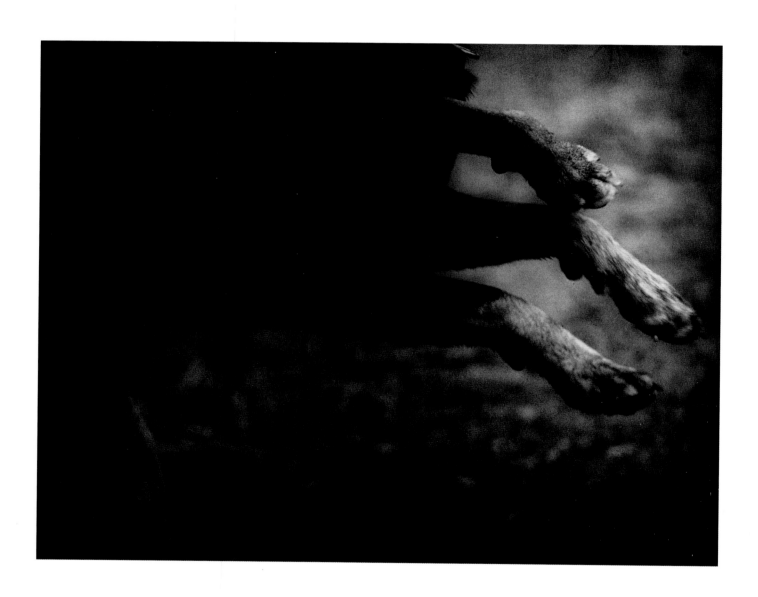

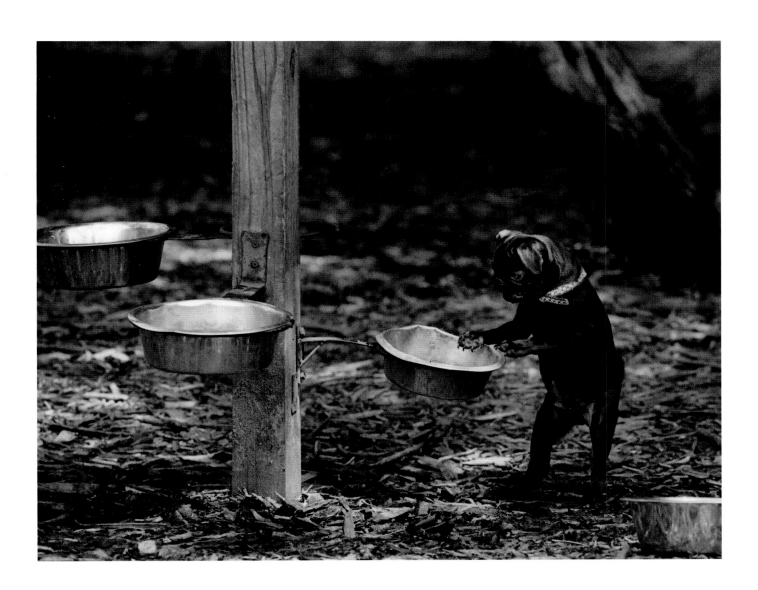

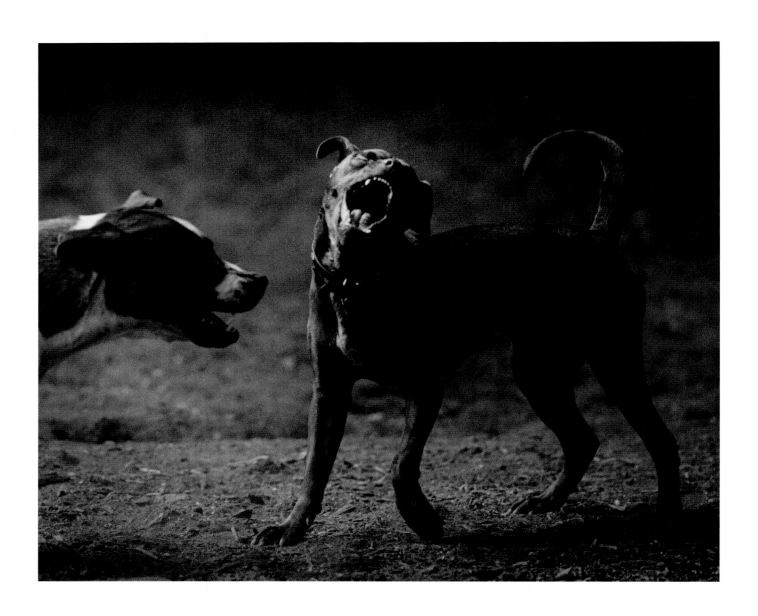

Afterword

The photographs for *Dog Run* began as a study of a Great Dane I saw galloping through a Minneapolis dog park. I had set out to make pictures of the movements of his muscles striding and flexing, as his short, shiny coat lent itself easily to such observation. But instead I ended up with several unexpected and more interesting images of his face, caught in snippets of seconds, making the most curious and dramatic expressions as he intensely chased a ball or followed his master's directions to move here and there. His body didn't turn out majestic, as I had thought it might, but instead was some wild tangle of legs and ears going every which way. At that point I still thought I might start a series on Great Danes, but the next time I visited the dog park, there were none in attendance. So I instead made pictures of what I saw—the various other breeds as they chased and fought and jumped and ran and rolled.

I was still interested in muscles, but dogs with longer coats don't reveal much in this direction, but do show a crazy, heavy whirlwind of energy. As I looked through

my film from the first few visits, it became clear to me that along with the relatively new phenomena of these dog parks (or dog runs) came a new photographic opportunity—that of shooting many, many dogs interacting with one another. The fenced-in nature of the parks means that the dogs are a captive subject, if you will, and there is constant turnover of animals as people come and go all day with their pets. The dogs are nearly always thrilled to be there, so there is much energy and craziness, thus much to see and shoot. As we edited and put this book together, it seemed to me that I had never seen such a series, which focused largely on these dramatic interactions.

I find that when I am in the dog runs, I am nearly invisible to my subjects. With all these new animals to smell and bite and taunt, the dogs could not care less about the humans sitting about. All these new pals! New enemies! They play like little boys throwing one another down a hill on the school playground. They practice in their play what nature has said they must know. Dominance, defense, breeding and

agility. And I am often nearly on top of the dogs in useful obscurity, making the first pictures of my life that actually make me laugh. Whether it is a study of a single dog or a pair feigning viciousness, they are hilarious and poignant to me in the intensity of their play. I find that the images fall somewhere between ominous and humorous. Which is exactly how I see the dogs themselves.

Acknowledgments

Thank you to my dad, Richard Crouser, for a lifetime of generous belief in his children. I would like to thank Audrey Jonckheer and the Eastman Kodak Company for their kind support through the donation of the Tri-X film and darkroom chemicals necessary for this project's completion. The following are also to be thanked for their interest and assistance in the making of these pictures and this book: Bill Phelps, Bill Clegg, Megan Newman, Amanda Tobier, and the dogs of the Lake of the Isles dog park in Minneapolis and the Tompkins Square dog run in New York. Thank you to Verve Fine Arts of Santa Fe, The DeSantos Gallery of Houston, Punto Arte of Barcelona, y a ella, el sol sobre mi cara.